# Shamiana

The Mughal Tent

# Shamiana

The Mughal Tent

❖　❖　❖

V&A Education project

developed and co-ordinated by

**Shireen Akbar**

V&A Publications

Published by V&A Publications

First published 1999
V&A Publications
160 Brompton Road
London SW3 1HW

Designed by Janet James
Photography by Brenda Norrish, V&A Photographic Studio
Project management by Geoff Barlow

Printed in Italy by Grafiche Milani

# Contents

## ACKNOWLEDGEMENTS

The Board of Trustees wishes to acknowledge the special and continuing support of The Paul Hamlyn Foundation for the museum's South Asian Arts Education Initiative, which has also received additional assistance from the Pilgrim Trust, the Sutasoma Trust, the Nehru Trust for the Indian collections at the V&A and Friends of the V&A.

The 1997 exhibition, 'Shamiana: The Mughal Tent', has been supported by donations from the Lloyds TSB Foundation for England and Wales, the Save and Prosper Education Trust and the London Arts Board, together with major funding from the Department of Culture, Media and Sport.

## DISCLAIMER

Every attempt has been made to accurately record participant statements from the information that was supplied by the groups and to acknowledge all those involved in the project. We apologize sincerely to any participants who may unintentionally have been omitted.

# Introductory Foreword

Museums and galleries have long been recognized as centres of learning, creativity and cultural exchange. The United Kingdom is fortunate in the richness of its museums and their collections – unique resources which communicate across boundaries of culture, language and time.

Without education there can be no culture. Like the talents in the Biblical parable, the value of collections lies in their use. The Department of Culture, Media and Sport has made a major commitment to widening public access to cultural resources and enhancing the quality of educational provision. Our report, 'Museums for the Many', offers standards for museums to use when developing access policies.

In recent years a number of museums have developed innovative and exciting education outreach programmes to encourage the participation of new and culturally diverse audiences. Such projects can provide a forum for staff and the public to share their expertise and skills. By working in partnership with external agencies, museums can widen the possibilities of the learning experience, which in turn enriches museum practice.

*Shamiana: The Mughal Tent* demonstrates the Victoria and Albert Museum's strong commitment to this broad initiative. The success of the project is an inspiration for everyone who wishes to develop the education potential of our cultural institutions.

**CHRIS SMITH**

*Minister for Culture, Media and Sport*

# Foreword

The Victoria and Albert Museum's project, Shamiana: The Mughal Tent, is part of a long tradition of innovative education work at the museum. Established after the phenomenal success of the Great Exhibition of 1851, with a mission to reach a wider audience – in particular students, designers and makers, as well as the working men and women who were the consumers of the designed and manufactured goods – the museum, led by its first Director, Henry Cole, provided a model for hundreds of other institutions in the United Kingdom and abroad. In the words of William Morris, who was closely associated with the museum in its early years, its task was 'the education of desire'; that is, the encouragement in others of the wish to enhance the quality of their lives.

Few museum projects in our own time can have achieved this so successfully as Shamiana. Evaluation of the project by Naseem Khan and Bunny Page revealed the scale of the impact of the project on many participants. For some women it offered a chance to meet and talk together in a community centre; others acquired through the project renewed confidence and respect in their own eyes and the eyes of others. For a few it also opened doors to new sources of employment. Whatever their reasons for participating, almost all who took part in the project found that in some way it had changed their lives.

Like so many innovative projects, Shamiana depended upon funding partnership between public and private sectors. We are particularly grateful to The Paul Hamlyn Foundation who saw the educational potential of the Victoria and Albert Museum's South Asian collections and have generously supported initiatives since 1991, and the Department of Culture, Media and Sport, who have made this project accessible to a wider audience throughout the United Kingdom and abroad.

As this book shows, the project used educational methodologies, such as group learning and the harnessing of the existing skills of participants, which are very different from the learning by imitation which Henry Cole encouraged a century ago. But he would probably have approved of the success of the project in drawing into the museum adults who, for the most part, had rarely visited museums before. So, too, might William Morris, who held the crafts skills and art and design traditions of the Indian Subcontinent in high regard.

Over the last decade, the Victoria and Albert Museum has played a leading role in the development of community education in museums. Our services now include South Asian and Chinese Arts Education Programmes, as well as new services for young people from local boroughs and other underrepresented groups. Much of the early impetus for these initiatives came from Shireen Akbar, whose example encouraged many inside and beyond the V&A to rethink the role of museums in society. It is a tragedy that she did not live to see the completion of a project, which in many ways drew together the threads of her whole professional life and work. Her influence continues wherever the works she inspired are shown.

The Mughal Tent Project crosses the boundaries between cultures and communities in our society. The initiative is a landmark in arts education in the United Kingdom.

**ALAN BORG**

*Director, V&A*

# Preface

I was the Director of the V&A when Shireen Akbar was appointed to the staff and I am often asked: 'What was she like to work with?' From a Director's perspective, the answer is simple: 'Inspirational.' But what does that mean? She was driven by an inner conviction of the need for action in her chosen sphere of work. In pursuit of her vision she could be stubborn and unrelenting, but her eloquence, beauty and elegance always persuaded those around her to follow her lead. She had a natural authority, which was occasionally exercised, with charm and complete ruthlessness, if it would benefit 'the project'. She could be exasperating in her single-minded pursuit of her goal but her goal was unique – like the woman – and I found myself assenting to some very strange requests, requests which I never regretted.

The last twenty years have seen many changes in the museum world. In particular, over the last decade, a handful of museums in the United Kingdom have been pioneering different ways of providing community education programmes for the people they serve. Foremost amongst these trailblazers have been the V&A and the Whitechapel Art Gallery, London.

Innovation and change are often driven by the vision of one individual or group of like-minded people. Fuelled by passionate personal commitment, they enthuse others to engage in activities and to develop ideas which earlier would have seemed alien, even inappropriate to them. Such exceptional people are rare and it was the good fortune of the Victoria and Albert Museum to employ Shireen Akbar as the first Education Officer in charge of multicultural education in 1991. She had unique insight into the position of South Asian women in this country and used it brilliantly to organize exhibitions and education programmes, which not only released a flood of creative energy, but allowed a wider audience to appreciate the vibrancy and breadth of Asian crafts.

Shireen Akbar, who died in 1997, was a courageous and innovative arts and community educator, whose work earned her not just an MBE, but an international reputation. Through her own example, she encouraged two generations of South Asian women – many of them lacking confidence and opportunities, and with English as their second language – to aspire to improve their lives. She also persuaded major museums to open their doors to the South Asian community. She developed arts education programmes which enabled thousands of women to join the threads of their personal experience in order to create works of art of extraordinary beauty and power.

Born Shireen Hasib in Calcutta, she grew up in an influential Bengali family which moved after Partition to what was to become Bangladesh. She was educated at Viqarunisa School and Holy Cross College in Dhaka and at Cambridge University, remaining in Britain to become a teacher in London.

In 1979 she took up a post at Bethnal Green Adult Institute as a language tutor for Asian girls and women. Always quick to perceive people's needs, she recognized that the racial abuse experienced by Asian women outside their homes – and the restrictions place upon them by their own communities – necessarily meant that language teaching should be only one aspect of their work together.

She established links between home and school for Bangladeshi children and acted as an interpreter for families without any English speaker. She would collect these children from school, so that their parents did not have to worry about their safety, and take them to visit places they would otherwise never have seen. At this time, in the early '80s, she was virtually alone in doing this kind of work, and her initiatives helped to redefine community education in London.

In 1982 she worked with the Commonwealth Institute to mount an exhibition of art work by Bangladeshi children. I remember visiting 'Our Exhibition' and being struck, not only by the forceful use of colour, but also by the many powerful

images specific to the experience of these children. Two years later, by now working for the Inner London Education Authority (ILEA), she travelled to India and to Bangladesh to collect resource material to support the multicultural work undertaken by teachers in the ILEA. In 1986 she helped to organize the exhibition 'Crafts of Bangladesh' at the Crafts Council, which travelled to Birmingham and Bradford. She then raised £5,000 to purchase the exhibition as a permanent resource for schools, adult education institutions and community centres in East London.

The success of 'Crafts of Bangladesh' persuaded the Whitechapel Art Gallery to employ her in 1988 to help to organize 'Woven Air' – an exhibition of Bangladeshi textiles – for which she also developed an acclaimed education programme. This proved to be a milestone in her work and was swiftly followed by a commission from the Museum of Mankind to create the exhibition 'Traffic Art', a collection of rickshaw paintings. Through all of these exhibitions, Shireen sought to reveal the continuity and depth of tradition in the arts of Bangladesh. The exhibitions aroused the interest of the visiting public in a little-known sphere of Bangladeshi culture and reaffirmed the artistic pride of an under-appreciated community.

When she joined the staff of the V&A, a period of immense fertility and achievement began. Building on her earlier experience in Tower Hamlets, inspired by the museum's rich South Asian collections and supported by colleagues who were in sympathy with her aspirations, she developed a remarkable educational experiment which will endure as a pioneering example of the way in which museums can, and must, communicate the magic and excitement of their collections to people of all ages and different cultural backgrounds.

Shireen conceived the idea of the Mughal Tent Project, and, generously supported by the Hamlyn Foundation, she brought it to fruition, against all odds. Using the tent as a symbol of home, of refuge, of dispossession, and of art, she

travelled the length and breadth of England inspiring groups of South Asian women to visit the alien environment of the museum galleries and to rediscover their heritage, their creativity and their self-esteem.

The women in these groups also made lasting friendships and created a focus within their communities which would endure and go on to demonstrate new ways of bridging cultural gaps.

The success of this project was a testimony to the power of simple actions to communicate across the divide of religion, education and community. It also demonstrated the power of a great national museum to act as a catalyst in this process of unifying people through the imaginative use of its collections. No one who participated in this project remained untouched by it. The power and beauty of these tent panels will be an abiding monument, not only to the indomniable genius of Shireen Akbar, but to the hundreds of women who took part in their creation, and through the project, found fulfilment and freedom.

**ELIZABETH ESTEVE-COLL**

*Former Director, V&A*

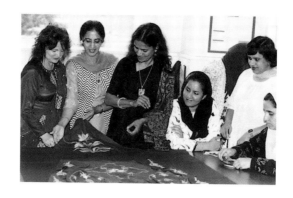

# Introduction
## The making of the Mughal tent

Shireen Akbar

(edited by Naseem Khan)

In Britain today, we are all members of a culturally diverse society, and all people, regardless of their age or origin, need and have the right to an education that prepares them for a life in such a society. Focusing on the collections in the Nehru Gallery, the South Asian Arts Education Initiative was set up to address some of these needs and to bring the cross-cultural education debate into the museum. After careful observation of the objects on display, we selected a subject for the project. In 1991 we established the Nehru Gallery National Textile Project, also known as the Mughal Tent Project.

We chose the idea of the tent for its many connotations [Shamiana is a ceremonial tent]. Tents can be romantic and exciting, such as nomadic or circus tents, or they can be physically or psychologically threatening, related to the feelings of being a refugee. All the participants of the core groups shared the common experience of immigration. For them the symbolism of the tent was powerful and easily understood. Groups of women from across the country were invited to design and make embroidered tent hangings on a scale equivalent to those at the V&A, following visits to the gallery. Ultimately they would all come together, in the form of a large Mughal tent that would be displayed in the garden of the V&A. It would be a collaborative process – all skills and knowledge would be pooled, undertaken mostly in community centres, adult education institutes, colleges and homes, with frequent visits to the museum.

Our initial focus group was Asian women for several reasons. They are the most isolated of all immigrant groups; they carry much of the responsibility for the informal 'cultural' education of their children; and they are skilled in traditional textile work. We were convinced that they would be motivated if the project measured up to their expectation. Moreover we had the resources to offer them gallery talks in their own language. However, the scope did grow, including women from the Middle East and North Africa, as well as 'native English' groups.

Once the museum was fully committed to proceed with this new and experimental approach to museum education, we organized a meeting of tutors and community group leaders to present the idea and explain the full implications of undertaking such a project. Long before museum visits were scheduled, as a first step in self-awareness, the women were encouraged to take ownership of their work by being involved in all decision-making. Several planning meetings were held at the V&A, and where possible, collective decisions were taken about the overall concept, design and fundraising.

Informal adult learning has its own range of strengths and disadvantages. We scored heavily on the side of motivation, but on the negative side we had to recognize that all the women would be overwhelmed with huge personal responsibilities of home management, child-rearing and career demands. Moreover, for a variety of reasons, many had been excluded from any formal education and were uncomfortable with the notion of structured learning. Many myths would have to be destroyed and some stereotypes to be challenged.

It was agreed to study aspects of Islamic art and the mihrab shape was chosen for the panels, to reflect the interior of a mosque. The size of the panels was standardized (10ft by 4ft) so that the finished piece would be unified. The colour red was favoured for the background material, because it was the colour of the imperial Mughal tents. Within these restrictions the women would be free

to express their ideas using a variety of textile techniques, including embroidery, painting, printing, appliqúe and collage.

When a group expressed an interest in the project, a member of the museum staff visited the group's centre, showed slides of the museum collection, and talked about the project. Many fundamental questions about museums, their collections, and their role in education and in leisure, were raised. The women were particularly concerned about their own, and their children's, alienation from the root culture. Museums like the V&A, with their immensely rich and varied collections, are a major learning resource and can play a significant role in broader educational issues. The women were astounded to learn that in the museum they could see objects of historical importance from the courts of the Mughal emperors. They could, in fact, come face to face with aspects of their history which hitherto they had only read or heard about.

Our visit to the women's centres was followed by an organized visit by the women to the museum. On these visits they were often accompanied by their children and by textile tutors and artists. They were given a guided tour of the collection in their own language by a member of the museum staff and generally made to feel comfortable. Having already seen the slides of the objects, they were excited to see the real things in the gallery. Much of what was discussed and learnt at the outreach session was tested and confirmed at this very first visit.

The afternoon session was a practical one. The group leader or artist encouraged the women to focus on a particular object and make drawings concentrating on material useful for their design. This was a very important step in their learning and was strongly resisted by most groups. We insisted on this stage, stressing that only a carefully structured practical activity could bring the objects closer and establish the first step in learning through making. From this point on there was a dramatic shift from discussion to actual creation. These early drawings and the experience of their first-ever museum visit became the inspirational starting

point for the group's tent hanging. We documented many of these occasions, as well as some outreach visits, through video and photography. Within the first year the video material was edited and used to recruit new groups and became the basis of distance-learning for those who were unable to visit the V&A.

As the project developed, we encountered several problems – some of them anticipated in the very first meeting, some new. The Asian community in Britain and other minority groups rarely visit museums. Most South Asian women bear sole responsibility for all activities centred around the home, often raising large families on meagre incomes. Most of the women on the project were from the inner cities, where unemployment is high and women are often forced to supplement family income by taking in piecework for the garment industry. For them, visiting museums is time-consuming, complicated, and expensive. Often they are not even aware that museum collections exist or that they can have access to them. Recreation is usually centred around the home, family members, or local mosques or temples. Many groups (not only Asian) find the museum atmosphere intimidating and unrelated to their lives.

Group learning through group activity – perhaps the single most important aspect of the methodology – did occasionally present problems. Individual egos needed to be placated and much time was spent at the design stage to ensure that all members of the group made a contribution. Understanding group dynamics became an important part of the learning.

Against this background, let us consider the work of a group of young adults from Tower Hamlets in London, undertaken as part of a museum community education initiative. All the young women were British–Asian second-generation immigrants with little or no direct contact with their root culture, and with minimal formal education about Asian history or culture. On their first reluctant visit to the V&A they were shown a selection of miniature paintings of the Mughal period, including one of the Emperor Shah Jehan, which caught their attention.

The appeal of the painting was not its technical excellence or interesting subject matter but the mystery of Mumtaz Mahal, Shah Jehan's wife, and the inspiration behind the Taj Mahal. By her very absence from the paintings, Mumtaz became a tantalizing figure and fired the imagination of the young women. Unlike many of the other groups, who had spent considerably longer on their panels using traditional embroidery skills, their panel in mixed media – based on their ideas of the invisible queen – was completed in only ten days. It is bold in statement and method of execution. At no stage organized as 'multicultural', it celebrates the best of multiculturalism. It gave the women a strong sense of their British–Asian identity, reinforcing some traditional aspect of their root culture whilst simultaneously allowing them the scope to express the modernity and freedom associated with contemporary western womanhood.

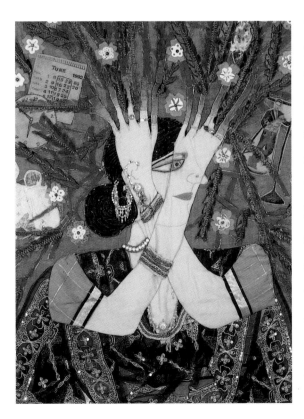

*Detail from 'Freedom for Life',*
*Tower Hamlets Youth Group, 1993*

The work does at first glance look very Asian. Mumtaz Mahal is depicted in all her glory, beautiful and bejewelled, rising from the roots that constrain her. She is shown in profile with her arms across her face as a mark of respect to her mystery. At this point the image is no longer a traditional representation of an Asian woman. Mumtaz's fingers explode into branches in which are placed the women's personal symbols of hopes and aspirations. Lodged at the very top is a book with the names of all the participants. It symbolizes the importance of education as the key to success and happiness. Amongst other symbols are money; the globe indicating the excitement of travel; and the clock and calendar expressing the

passing of time. Nearby, the scales of justice are finely balanced between a man holding the baby and a woman carrying a briefcase.

The textile is packed with ideas about education, career aspirations, relationships, gender and other themes which concern all contemporary young women regardless of their social or cultural moorings. This work fuses ideas drawn from two distinct worlds, South Asia and Britain, and reflects a synthesis in visual art from diverse cultures. The technique of traditional Indian embroidery is combined with western mixed-media approach to collage, printing and painting. Conventional images and decorations inspired from Indian art are merged with western symbols from everyday life. Mumtaz Mahal is transformed from a beautiful passive woman to an indestructible symbol of strength, power and hope.

In little more than just the first year, fourteen panels were completed, not all of them with as much narrative content as the Mumtaz panel. They covered a wide range of topics, including literacy,

'Freedom for Life',
Tower Hamlets Youth Group, 1993

multicultural Britain, marriage, religion and freedom. Each is imaginative and distinct, topical, but inspired by the collection.

Since the project was rooted in a particular collection, we emphasized the need for all groups to visit the museum. Whilst this remained an achievable objective as long as the project was located in England, requests from groups in Ireland and Scotland, and later from overseas, made us review our original aims and

objectives. Museum educators and others involved in informal adult education expressed great interest in the concept and the methodology that had evolved. We too were keen to extend the project and test the methodology in a non-V&A context and thereby establish the universality of its underlying principles. We encouraged groups who were unable to visit the V&A to look at South Asian collections at their nearest museum. As a direct result of this, a group in Dublin (comprising Irish and Asian women) began to work with the Chester Beatty Collection, as did another group with the collection at Madras Museum. The success of this new and unexpected development heightened the women's self-confidence and resulted in the mushrooming of many groups all over the United Kingdom and abroad.

Besides acting as a catalyst for the formation of local groups and providing a focus of activity for existing ones, the project has brought together individuals and institutions at a national level. At the local level many panels were displayed in community centres, as well as museums, in Birmingham, Leicester, Blackburn, and Taunton, and abroad. Having exhibited their work at Leicester Museum, the women in the Leicester Group took their skills to local schools, where they were encouraged to run workshops and offer demonstrations. Mehfil-e-Tar, a well-established group in Bedford, ran its own co-operative and opened a shop. These women, too, were involved in workshops, demonstrations and presentations. The makers as a whole wrote about their work and discussed it on local and national radio and television. At opening ceremonies of exhibitions they gave presentations to dignitaries and their own families and friends. In rural Somerset, a group of English women used the project as an introduction to South Asian culture as they attempted to understand the cultural diversity of today's Britain.

The project was also piloted in schools to assess its suitability for the national curriculum and was used as part of a GNVQ course in art and design in further

education. The educational aspect of this project has extended beyond its original aims; that is, understanding museums and their collections through group participation and practical work.

This method of working with a museum has excited educators and women's groups themselves. The public acknowledgement of their skills described above has contributed greatly towards raising self-esteem and prompted a new independence of action. The tent panels that resulted have revealed an amazing pool of hidden creativity, skill and talent. Many are of outstanding merit. It is important however that the work of these women and of the Asian community be seen as a vital part of British culture, and not as something separate or exotic.

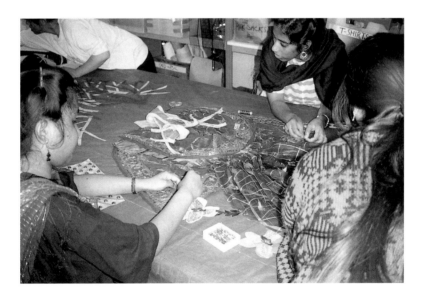

*Tower Hamlets Youth Group working on 'Freedom for Life'*

The benefits that the young Bangladeshi girls of Tower Hamlets described so eloquently are applicable to the wider participants in this vast project:

Our panel is of a woman symbolizing freedom. Shireen Akbar told us the story of Mumtaz Mahal. She is famous because the Taj Mahal was built for her. There aren't any pictures of her, so we don't really know what she looked like. She is a mystery woman and we wanted to know more about her. We worked from a miniature painting that was an artist's idea of what she might have been like.

That's why her face is covered – because no one has seen her face. It is out of respect – to preserve her mystery. She is wearing Mughal-style clothes – the sort Mumtaz might have worn. We chose the colours according to their meaning in Islam: brown means roots and fertility; green is the colour of paradise and self-assertion; yellow is powerful, it is the colour of the sun. The roots are holding her down, but her branches are blossoming at the top. She is breaking free from what is holding her back. The roots are trapping her. The symbols in the branches are our freedom of choice. They are our rights as women: to education; to choose a career; to earn our money and be financially independent; to choose our own husband and the kind of marriage we want; to travel; to choose our own time to do things.

We felt the book should be at the top because it symbolizes education. If you are educated you have better opportunities, more power. If you have education you can have all the others.

# Changing Lives

Fahmida Shah

Cultural diversity is not a new concept in Britain. Historically it has always been a country of people with different histories, cultures, beliefs and languages – Goths, Vikings, Romans and Saxons have all made a home here. In fact it would be fair to say most people living in Britain today are either immigrants or descendants of immigrants. This century has witnessed settlement by large numbers of immigrants from the West Indies and the Indian subcontinent. Migration results in changes for all living in the community, the newly arrived and the indigenous population. Whilst the new communities contribute their own unique culture to the development of a new society, they also participate in existing traditions of the society they are joining. The process of settling into a new country, and most importantly, becoming accepted by local people, is usually long and difficult for all members of the community.

Many of the Asian women participating in the Mughal Tent Project migrated to Britain for economic reasons during the 1950s and '60s. Some found employment in semi-skilled jobs whilst the majority continued their lives in this country as housewives. They carried the responsibility of bringing up their children and the day-to-day running of a home. Their social contact was mainly with other Asians and therefore they had little reason to learn the English language. It is the growing generation and cultural gap with their children which spurred many of the women to address their isolation and loneliness. Some had taken the first important step of attending local community centres to learn English as a second language, whilst others needed encouragement and support.

It is these women who were the initial focus of the Mughal Tent Project which later grew to encompass much wider groups. For many of these women, attending local community centres was a major step in their struggle to adjust to the demands of their new life. To be invited by the Victoria and Albert Museum to take part in a national textile project was an even greater leap forwards.

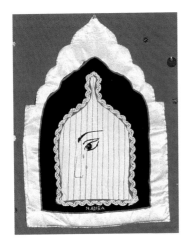

*Detail from 'Islam Now',*
*Falkirk Asian Women's Group, 1995*

The majority of the panels carry clear messages, with mixed emotions, from the women about their past and present lives. *Islam Now*, a panel made by women in Falkirk, Scotland, makes a strong statement about what it is like to be an Asian woman living in an alien culture, where the pressures of being a wife and mother can at times almost seem imprisoning. One young woman in the group depicted this by stitching a gilded cage surrounding an eye that sheds a tear. Another group from London called their panel *Hope*, representing in its design women in different roles: a working woman earning a living using a computer or a sewing machine; studying in the library; playing with children and enjoying motherhood.

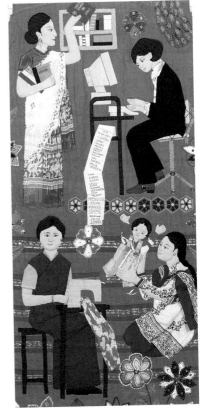

*Detail from 'Hope',*
*Hopscotch Asian Women's Group, 1995*

Unfortunately, over the five years of this project, we, along with the youth and community workers who managed or co-ordinated the groups, lost contact with many of the women and young girls from the earlier years. However, some women continued their links through other programmes of the museum and became a source of inspiration for many others who were still isolated. The aim of this essay is to allow the women to speak for themselves

about the changes in their lives and attitudes through their involvement with this project. Whilst these statements do not reflect the opinions of all the women, the sentiments expressed represent experiences of the majority of them.

The Shamiana Project provided a common goal for the communities, both Asian and non-Asian, to demonstrate their creative skills and to celebrate their rich cultural heritage. Asian women worked next to non-Asian, the young next to the old, children with their mothers and grandmothers. Many women felt proud of their achievements as individuals and as part of a community.

'I took my work to parties with me and I did it sitting in front of the telly. People asked me about it and they admired all the hard work', said one woman.

Another commented: 'My children are proud of me and encouraged me, and I have been able to tell them all about Mughal tents.' For one woman from Leicester, who was reported to be isolated and depressed before joining the group, this was a self-healing process which helped her to come to terms with being in a new country and a new environment. It has been reported that she subsequently joined a part-time foundation course in Art & Design.

A group leader in London said of one woman in her group: 'Before she used to wear dark colours all the time. Now she comes in bright coloured saris and puts on her jewellery.' Some women realized their own potential and went on to run courses in dressmaking and traditional embroidery for Asian women in their local community and adult education centres.

Another strength of the Shamiana Project was its encouragement of group learning, which provided an opportunity for the women to share their anxieties, hopes and aspirations for their future. Many of the women still had memories of their lives when they enjoyed the support provided by the extended family network. They were accustomed to big verandas and open spaces of their home countries, but their lives in Britain were confined to the four walls of their home,

with family and friends not always at easy reach. Working together in a group rekindled distant memories and also demonstrated new ways women could build up networks of support for themselves. Many of the United Kingdom's groups that joined the project in the latter years comprised women from diverse backgrounds – Hindus, Sikhs, Christians and Muslims. One woman commented: 'I never thought that I, as a Hindu, would work on an Islamic thing.' 'We were a

social group with differing views, yet the finished work comes across as coherent', commented another. A group of non-Asian women in rural Somerset joined the project in 1993 because they wanted to understand the lives of people with different backgrounds and perspectives.

*Detail from 'Pot of Life',*
*Aston Hall Asian Women's Textile Group, 1993*

The women from Birmingham discussed the value of group work in breaking down barriers between generations in their panel entitled *Pot of Life*, which, in their words, describes the cycle of life: 'One seed can grow into a wonderful creation, starting from the soil in the pot, deep into its mother's womb and ultimately flourishes to show to the world its splendour and beauty. The tender young leaves represent the youngest members of

the group. As the tree grows older it changes its forms and colours and with each season it gradually fades away and new leaves begin. This shows how experiences of life skills have been shared and passed on to the younger generation – mother to daughter. This is also how we learnt our skills and how we can keep the skills alive by passing it on to our children and our children's children.'

Balbir Kaur Nazran, a participant and a group leader from Aston Hall Asian Women's Textile Group in Birmingham described the impact of the project on

her life: 'I am a mother of three and worked as a clerk typist in Birmingham. My work with the Aston Hall Women's Group changed my life completely. My childhood desire was to be a teacher and my ambition in life is to help others lift themselves up from their misery and burden of life and this project has given me the chance to do this. Since I entered Aston Hall it has opened many other doors to me. I have since taught in schools, community centres and colleges teaching embroidery. I am also working at the Mental Health Centres for depressed people using embroidery as a therapy for self-healing.'

Young people explored issues of growing up within two strong cultures and through their panels expressed their aspirations for the future. Firth Butt, a participant of *South of the River* panel from Bedford, also shared Balbir's experiences, but from a young person's point of view. 'All the young women involved with the panel grew with every stitch that went into making the panel. Most of us when we came to the project were shy, withdrawn, and, like myself, without much direction in our lives. At last, I actually discovered "me" and what I wanted to become. We have all blossomed in our own ways and have gone on to achieve that which we would never have dreamt to be within our grasp. We have not lost our Asian identities, in fact, I would say that we are now closer to it than we have ever been. Those who try can achieve what they wish, as long as we ourselves remember that we should integrate but not assimilate.'

My initial experience of the Victioria and Albert Museum was as a textile art student seeking inspiration from its vast collections of arts and crafts from different parts of the world. Through this interaction I had built up a strong impression of the V&A as largely representing a Eurocentric perspective on its collections – one that I felt I could never be a part of. Whilst I was not a participant in making any of these panels, as a South Asian woman working on the Mughal Tent Project, I found a new perspective on the V&A and the place of museums generally within our society. Having already met Shireen through my

work on another women's project in Bedford, I realized we shared similar concerns for the plight of women in our culture and the role institutions can play in assisting them. The participation of hundreds of women and children who have given their commitment to this project over its five years has demonstrated the Asian community's desire to engage with cultural institutions of this country, and their willingness to accept changes in the process of discovering a new British–Asian identity. For me, the Shamiana Project reaffirmed the importance of opening institutions such as museums to people from all walks of life. This would enrich not only our society, but also make visits to the museums a living interactive experience.

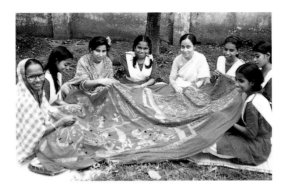

# The Panels as Works of Art

Deborah Swallow

'The role of embroidery in the construction of femininity has undoubtedly constricted the development of the art. What women depicted in thread became determined by notions of femininity and the resulting femininity of embroidery defined and constructed its practitioners in its own image. However, the vicious circle has never been complete. Limited to practising art with needle and thread, women have nevertheless sewn a subversive stitch – managed to make meanings of their own in the very medium intended to inculcate self-effacement.'[1]

*Rozsika Parker, 1984, 1996*

No one visiting the exhibition 'Shamiana: The Mughal Tent', in any of its incarnations, could fail to be moved by the visual power, strength and vitality of the textile panels. Few of us who were initially involved in the Mughal Tent Project had envisaged the technical skill, creativity and virtuosity that would be released, and the richness of the objects that would result from it.

The body of textile art that this project has engendered deserves more than unthinking celebration however. It also warrants critical attention. It adds a further chapter to the history of women and embroidery, and raises again a whole set of issues relating to the interconnections between embroidery and femininity in Europe, contributing a fascinating multicultural dimension to the debate.

From its inception, the Mughal Tent Project was about the empowerment of Asian women, about giving them and their children access to their root culture and history, about increasing skills. It assumed as a starting point that Asian women were skilled in traditional textile skills.

With embroidery, we employed a textile theme which was very non-threatening to the women. They knew they could do embroidery. They understood what it was, even if they didn't understand the aims of the project. They knew how to do it. And (for) their men folk this was important. 'OK, women can do embroidery. That's alright. That's no threat. We can handle that. They can go out and they can do some embroidery.' (Geraldine Bone, 'A' Team Arts Education)

Many of the panels – for example, the *Taj Mahal* panel by Burton Asian Women's Textile Group, the *Pot of Life* by the Aston Hall Asian Women's Textile Group, *Beauty and Elegance* by Tipton Muslim Women's Group and *Peacock* by the Foundation Art Group, Tower Hamlets – reflect these superb traditional skills in the depiction of familiar South Asian celebratory themes. In *South of the River* traditional embroidery is used to make a specific point: 'We haven't lost our culture. It has been retained and you can see that through the solid border of embroidery that goes around the main feature of the panel.' But many of the motifs are in fact being used for the first time in the context of large-scale embroidery.

For many participants, however, both the process and the outcomes were visibly new. The young artists and tutors, both Asian and non-Asian, who worked alongside Shireen Akbar with the first groups, were themselves the products of British art schools, used to working with textiles as an 'art' rather than a 'craft' medium. They encouraged the women to take the forms and symbolism and techniques seen on objects in the Nehru Gallery and to use them in a contemporary way. 'We were wanting the women to say something about their own lives and their situation in Tower Hamlets... and we felt we were giving status to their skills as embroiderers, but also to their thoughts and opinions. It was as if what they felt and what they knew had really no importance or significance, so they weren't used to putting it into words anyway. They weren't used to talking about it.' But talk they now did, and experiment with new techniques. And what resulted drew on all the artistic and cultural traditions the groups represented. In turn their panels also had an impact on the work of groups who joined the project later.

A powerful visual theme that appears again and again in the panels is the 'Tree of Life' or the 'Flowering Tree'. Motifs of this sort run through the Nehru Gallery, appearing as flowering plants on Mughal tent panels, shawls, waist-cloths, wooden boxes, jade and metal vessels, and as flowering trees on painted and printed cotton textiles made in India for the seventeenth- and eighteenth-century European markets. This Indo–European flowering tree itself has polygenous sources, combining disparate cultural elements: Hindu, Islamic, Chinese and European, and at the same time appearing to the westerner to resemble an even more ancient motif – the West Asian Tree of Life. It is not perhaps surprising therefore that the motif struck chords amongst the participants, and provided a structure on which, sometimes literally, to hang their concepts and images. Uninhibited in the use of mixed media, participants created their trees using embroidery, collage, appliqué and painting techniques. In *Ramadan/Eid*

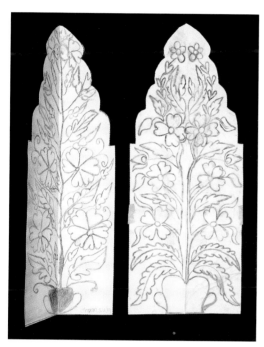

*Drawings on paper showing tree designs for the 'Ramadan/Eid Tree' panel*

*Tree*, with its cross-reference to the traditions of Christmas, the tree structures the arrangement of beautifully embroidered hands making offerings. In *Freedom for Life*, the tree itself becomes the woman, the woman the tree. For the City Challenge Language 2000 Group, it becomes *The Tree of Knowledge* – the products and symbols of power gained through knowledge hanging from its branches. In *Food for Life*, rooted in water thick with fish, it rises up through the piles of European and Oriental fruit and vegetables and shelters them

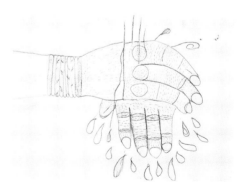

*Drawing on paper of hands for the 'Ramadan/Eid Tree' panel*

with its branches. In *Hope*, flowering plants clamber up the pillars that frame the women pursuing their various occupations, and a tree provides housing for doves, symbols of peace and love. For Highfield Junior School's vibrantly painted

panel , *The Tree of Life*, and for Montem Infant School's *Flowers and Birds*, the tree is the primary theme. In the panels created by Windsor Girls' School, *Bird* and *Migration*, the tree becomes the route for migration from water, through land to the air. And in *Reflecting a Vision of South African Culture*, a tree-like structure takes on a more abstract form, rising up to shelter the major religions of the world and culminating in a burning lamp – a symbol of light. In *Two Landscapes*, a panel created by English women in Somerset – who had no prior knowledge of South Asia – the tree simultaneously separates and links the two landscapes of its title, its roots drawing from water which feeds both India and Britain.

In commenting on these panels I have taken a viewer's prerogative, implying an interpretation as I describe them. But in part this interpretation has depended on things said and written by the creators themselves. In many instances the record of the process of creation and the interpretation of intended or received meaning is immensely rich.

Basically our panels were a reflection of the point of view of young people living in Britain today, mainly I mean from our own personal perspective. Some of us were born and basically brought up in Bedford. We thought that having the two trees, they represented the two cultures of ourselves, of growing up in both the Eastern and the Western. We had our own culture that our parents had taught us, and we'd been brought up in this world with outside influences, seeing the best of both worlds.

But the Bedford panel carries more complex messages:

We have two *jalis*[2] on our panel and the *jalis* represent the barriers which still do exist.... The *jali* also represents the young women in our community who are also held back, well not entirely held back. But there are these thoughts that have been placed down by men, you know, dominating Asian society, saying that a woman can only do this and not much more. And the *jalis* just say that although these barriers do in a sense still exist, they've reduced slightly. I mean they're not as strong and rigid as they used to be. You can actually get through. That the ideas are changing and you know you can actually do something else as long as you have the will power and the determination to do so. (Firth Butt, Bedford Women and Girls' Group)

In many of the panels the symbols carry highly specific personal meanings and local or historical references. The leaves on the Bedford Women and Girls' Group panel are inscribed with the names of each of the participants, and on each is a glass bead to represent the tears shed when Shireen and their own embroidery teacher, also represented in a symbol at the base of the tree, died during the course of the project. *Nowhere to Run* by the Kanwal Girls' Group from Burnley, though representing a general horror of war, is informed by their families' experience of the Bangladesh war of independence and the history of conflict within South Asia. *Asian Women in Action* vividly portrays glimpses of life in Blackburn. *Working Mothers and Daughters* by Aparajeyo, a group of girls rescued from the streets of Dhaka, uses traditional *nokshi kantha* embroidery techniques but depicts, in a series of vignettes, the working life and concerns of women in Bangladesh; and a Bengali group in Mitcham use the same stitch in *Nokshi Katha* to recreate scenes of their childhood in rural Bangladesh. The Natal Museum Group's panel refers to key moments in the history of the Asian community in South Africa and of apartheid more generally. *A Recipe for Unity*, by the Ikat Arts Group of Malaysia, observes orthodox Islamic geometrical design but new forms of calligraphy, manipulating words by weaving and tying fragments of recipes, memories and lost stories into a complex abstract design.

Group dynamics themselves influenced design. In the case of groups of mixed religious background, there was an over-riding need to agree that all religions had common aims and goals and to represent them symbolically in the panel. In groups of mixed age, the need to respect different approaches and techniques of working was also marked. The project, with its western assumptions about the primacy of the skills of the pen, had both explicitly and implicitly encouraged the development of skills in drawing. Interestingly, for some of the younger women educated in the UK, the discovery of alternative methods of artistic production and communal creativity was revelatory, socially unifying and healing.

….one lady was saying 'I've never done embroidery for forty years' and there she is sitting. They're doing embroidery and actually looking at what she's doing … so they learnt a lot of skills… from her. I picked up colour what they were picking. They were not picking colours we would blend in, they were picking colours that I would never imagine or anybody would imagine. They just picked colours that they think what's right inside their feelings. It's all coming (from) within themselves; it wasn't coming as we were taught in school – that you do this, look at it, draw it, and then you paint it, and then you do embroidery. It wasn't anything like that. We didn't do any painting. We didn't do anything like it. We just went directly to the fabric because the feeling was going directly. And this is what I myself have picked up, what this embroidery brought us… and especially I took it seriously because we all went back and started talking about the time we'd spent in India, Pakistan and Africa. Every evening under the shade of a tree they were doing embroidery. They were sitting together talking, or maybe gossiping or whatnot. But it was a healing process. It was a unity among themselves. They were sharing problems.… It wasn't just embroidery for itself. (Balbir Kaur Nazran: Birmingham)

These comments reveal a great deal about the social context of embroidery production in those communities in South Asia where embroidery played a significant role as a domestic skill. In the Subcontinent, much artistic production continues to be domestic and remains closely associated with annual or life-cycle ritual. Much work is ephemeral – floor or wall designs that will be rubbed out or painted over, garments and furnishings that will be heavily used, images which will be immersed in water at the conclusion of a ritual process. In all these cases the process of production is more important than the finished product – a dimension of creative interaction which was recognized and valued afresh by project participants.

The panels also demonstrate that there are artistic continuities between the embroideries of Gujarat, Rajasthan, the Punjab, Kashmir and Bengal, and those of their overseas communities, that go beyond the replication of motif. In those regions, embroideries for personal wear or household decoration may create their effect from the manipulation of geometrical shape and bold colour. Or they may achieve a different sort of harmony from the apparently random arrangement of elements from epic and folk-tale, ritualistic motifs, luxuriant

vegetation with roaming animals, articles of personal use, vehicles and domestic animals, verses and rhymes, some philosophical, some colloquial. Many of these themes, accommodating not surprisingly to a changed or changing life-experience, appear quite clearly in the panels. But the panels also stand within the history of western embroidery of the twentieth century. They remind us of the banners of the Suffragettes and of more recent groups of works which used the 'woman's art of embroidery' to reflect on, and challenge, assumptions about women's traditional roles.

The history of western embroidery has recently recovered the memory of women's roles as professionals in the period before the Renaissance. For the South Asian women on this project, paradoxically, the excitement was to discover that men had been, and still are, embroiderers in the Subcontinent.

We actually ran an embroidery group ourselves, and now we're going to get boys involved.... Hopefully they're going to come down on a trip to the V&A. And it's not going to be based on embroidery as such, but on having self-expression through textiles, seeing that it's not a female activity, that it is for me. I mean going back to the Mughal period it was men, and still to this day it is men who do embroidery professionally... but we've still got this notion that it's women's work, but it's not.

As Rozsika Parker argues so cogently, the definitions of art and artist – so weighted against women – have continually shifted over the centuries and will be further transformed in the future. The Mughal Tent Project, so brilliantly conceived by Shireen Akbar, is playing an important role in that transformation.

Notes

[1] Rozsika Parker, *The Subversive Stitch: Embroidery & the Making of the Feminine* (London, The Women's Press Limited 1984, 1996).

[2] *Jalis:* open-work screens used in Mughal and Rajput buildings to provide windows and ventilation both externally and internally. Women in purdah could look out at public events through jalis from their secluded quarters without being seen.

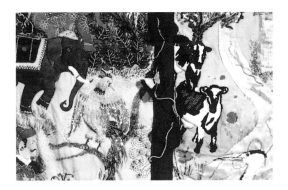

# Learning Across Cultures:
## The educational significance of the Mughal Tent Project

David Anderson

'By imbuing sensory values with social values, cultures attempt to ensure that their members will perceive the world aright. When sensory orders express cosmic orders, cosmologies are not only read about or heard of, but lived through one's own body.... These sensory cosmologies make us aware of the many different ways in which cultures shape perception, and the inability of western models to comprehend such sensory and symbolic diversity. When cultures are approached on their own sensory terms rather than through the paradigms dictated for them through the West, what we discover are not world-views or oral/aural society, but worlds of sense.'[1]

*Constance Classen, 1993*

In the West, as Constance Classen points out, we are accustomed to thinking of perception as a physical rather than a cultural act. If perception is culturally defined, how much more so are the processes of making and learning.

In 1993, I travelled with Shireen Akbar to India and Bangladesh. There we studied the educational work of a range of non-governmental organizations, including the Grameen Bank. The philosophy of the bank is the opposite of that of most banks; it lends only to those who have few possessions. As a bank it seems to be extremely successful – all but a few per cent of its loans are repaid – but more important from an educational perspective is its social and educational impact.

The bank is now established in most villages in Bangladesh. It has transformed the lives of many of its borrowers, and especially women, who make up ninety per

cent of the recipients of loans. The bank's success in organizing and supporting such a large portion of the population rests on its network of thousands upon thousands of groups, who must approve any loan to a member of their group, and who undertake to repay the loan if the borrower does not. The Grameen Bank has been phenomenally successful. Yet some of the educational methodologies it uses with its adult members – such as role-learning and controlled role-play – have largely been out of favour in education in the United Kingdom for many decades. Seeing these methods used so successfully in Bangladesh prompted me to question some of the assumptions about learning of contemporary educators in the West.

It is evident that the Mughal Tent Project had deep roots in South Asian educational traditions, as well as those of the UK. There were many features in common between education for development in rural Bangladesh and the community education work undertaken by Shireen and the arts workers and community workers who implemented the project with her in the UK. These included a commitment to social change, a people-based mission closely related to participant needs, long-term rather than short-term goals, development of programmes through groups with strong existing networks, delegation of much decision-making to participants, and a clear philosophy and purpose which was understood by everyone involved and which underpinned the whole project. Of course, these features are not unique to some South Asian cultural contexts and the Mughal Tent Project. On the other hand, that there was a connection between these, and that it was a consequence of Shireen's own background and those of the group involved in the project, is unlikely to have been a coincidence.

In any case, it is difficult entirely to separate western and South Asian educational methodologies. It may only be in recent years that museums in the UK have been aware of ways of learning that are different to those of their own culture, but in

the adult education field this had been understood much earlier. Lalage Bown has suggested that there are four strands of international thought on adult learning which have emerged as a result of the influence of delegates from non-western countries. These are (1) the placing of adult education in the context of lifelong learning instead of regarding education as preparation for life and adult education as a remedial exercise; (2) the acceptance of a very broad definition of adult education, including support for informal and self-directed learning; (3) the relationship of adult education to public policy, and in particular, to development policy; and (4) a concern for positive action in favour of the educationally underprivileged.[2] All of these influences are evident in the Mughal Tent Project.

One consequence of the influence of non-western educational methodologies has been a far greater emphasis on the social and political role of adult learning – a perspective adult education institutions in the UK have been far more ready than museums to accept as relevant to their work. Another is the greater emphasis given to adult learning. India in particular has made a significant investment in innovative adult education programmes, and has allocated a larger portion of its education budget (ten per cent) to adult education than any country outside Scandinavia.

One of the most significant features of the Mughal Tent Project is the challenge it posed to the traditional belief, still held by many museum professionals, that knowledge and expertise reside mainly with ourselves and our academic associates; and that the purpose of our educational work is to make our research discoveries available to a non-specialist audience. This model of one-way transfer is no longer sustainable theoretically and bears little relationship to what is actually going on in museums. This is not to deny the value of collections-based research, but to recognize that learning through museums is a far broader, more inclusive and more interactive process than this traditional model allows.

The Mughal Tent Project challenged a number of assumptions about learning in museums: that it must be expert-directed; that the public is dependent upon the expert; that the prior experiences of museum users are irrelevant unless they happen to be experts on the subject as well; and that members of the public want information about the collections essentially for its own sake rather than for any practical purposes related to the rest of their lives. Instead, the project was established on the basis that museum staff and museum users can work in partnership towards a common purpose, and that the experience of both participants and other museum visitors is enriched by a collaborative approach.

The foundation of the Mughal Tent Project was, then, self-directed learning – that is, learning undertaken through a sustained personal interest, rather than in accordance with the requirements of a curriculum defined by a formal educational institution or other organization; managed so far as possible by the learner; drawing upon the individual's own background and experiences; task – or problem-centred; and motivated by internal incentives and curiosity rather than external pressure. Museums, being resource-rich learning environments, are ideal centres for self-directed learning.

Here, too, cultural issues are relevant. Stephen Brookfield, one of the leading researchers on self-directed learning, noting that most research on adult learning has been based on observations of white, middle-class males, has found that 'learning activities and learning styles vary so much with physiology, culture and personality that generalized statements about the nature of adult learning have very low predictive power.'[3]

Brookfield challenges uncritical acceptance of the concept of self-directed learners who take the initiative in designing their own learning experiences, diagnosing their own needs, locating resources, and evaluating their own learning. He distinguishes between 'field-independent' learners, who are

analytical, socially independent, inner-directed, individualistic and possessed of a strong sense of self-identity, and 'field-dependent' learners, who are extrinsically orientated, responsive to external reinforcement, aware of context, know things holistically, and are cognizant of the effect their learning has on others. Field-dependent learners, he notes, are said to found in Mexican and indigenous American cultures, for example, whereas white American and Northern European cultures generally support field-independent functions. A field-independent learning style was also preferred by many adult educators in North America and Northern Europe, yet Brookfield found in his research that successful self-directed learning was most likely to occur in field-dependent learners, who developed their learning through networks based on face-to-face encounters, without employing abstract conceptualizations.[4] In these terms, the Mughal Tent Project, with its strong emphasis on group learning and the development of networks (a process that quickly took on a life of its own and extended far beyond the initiative of the V&A), clearly fostered field-dependent learning on the part of participants, rather than the field-independent learning most characteristic of Northern Europe. As such it provides a valuable model for other museum projects.

The project was also significant for its emphasis on inter-generational learning. Of course, some groups did not include the full age-range of adults from teens to elderly people, but many did, and the project as a whole was certainly designed to do so. This heterogeneity undoubtedly enriched the learning of participants, and allowed greater opportunity for individuals to contribute according to their own levels of confidence, skills or preferred learning style.

The decision to target the project towards women was deliberate, and enabled Shireen to build upon her long experience of teaching and youth work with South Asian women and girls in East London. However, the project did have a secondary educational impact – particularly within the families of the women

who took part in it. One child described his pride in seeing his mother, as a South Asian woman, come into his classroom and stand and speak confidently in front of his classmates about the project – an experience which clearly reinforced his own self-esteem and confidence. Another woman who had taken part told Shireen that she had discovered, as a result of the project, that western institutions need not undermine South Asian cultural values, and would, therefore, allow her daughter to go to college after she left school. Many husbands who were initially cautious about the effects of involvement with the V&A became proud and enthusiastic supporters of the work of the women, some helping with child-care to enable their wives to take part. Of course, not all experiences and responses were so positive, but an evaluation of the project undertaken by Naseem Khan and Bunny Page suggests that a majority benefited from the project, and some felt it had changed their lives.[5]

One other dimension of the project should also be mentioned. This is the learning of the V&A staff who participated in the project. It is perhaps easy to forget, eight years after it started, how much of a new departure this was for the museum. When Shireen was first offered the post of South Asian Arts Education Officer, some of her friends urged her strongly not to accept a job at a national institution whose reputation in the South Asian community was ambiguous. They felt that Shireen's own credibility with that community might be jeopardized by her association with the V&A.

It is a testimony to Shireen's courage that she nevertheless accepted the post and set about initiating projects that were close to the needs of community groups. Her approach was firm but gentle and non-confrontational, and she won widespread support at all levels of the organization. Certainly, the educational methods adopted by her and others closely involved in the project were different from anything the V&A (or most other museums) had seen before. The museum had, and still has, much to learn about issues of cultural difference, ethnicity and

language. Through this project, it engaged for the first time in a sustained programme of educational activities outside its walls, and discovered some of the steps it needed to take to make the institution more welcoming to people who are not already confident museum-visitors. These lessons have wide application and have informed other projects, including our programmes for the Chinese community and for young people. In this small way, the V&A has taken steps towards being a learning organization.

The educational impact of the Mughal Tent Project continues to spread both inside and beyond the V&A. This is a fitting testimony to Shireen and to her work as an educator.

*Notes*

[1] Constance Classen, *Worlds of Sense: Exploring the senses in history and across cultures* (London, Routledge 1993), pp.137-8.

[2] Lalage Bown, 'Adult Education in the Third World' in Tight, M. (Ed.). *Adult Learning and Adult Education* (London, Routledge 1983), vol. 1, pp.38-49.

[3] Stephen Brookfield, *Understanding and Facilitating Adult Learning* (San Francisco, Jossey-Bass 1986), p.25.

[4] *Ibid.*, pp. 41-2.

[5] Asian Leisure and Arts Planners (ALAAP). 'The Mughal Tent: A study of the Nehru Gallery National Textile Project at the Victoria and Albert Museum', unpublished report for the Victoria and Albert Museum (London, September 1993).

❖ ❖ ❖

# The Panels

❖ ❖ ❖

# Islamic Panel 2 · 1992

Leicestershire Museums Group
Leicester

# Islamic Panel 1 · 1992

Leicestershire Museums Group
Leicester

'When I am working on this project, I forget everything. It is meditation for me.'

PARTICIPANT

'Symbolically, our panel means unity, which I consider quite important for this unique project. I think this project has inspired me to go forward in the arts.'

PARTICIPANT

'Women from Leicester were recruited through crèches in the primary and secondary schools. None of them had been involved in an arts project before. A visit to the V&A for some was first time out of Leicester and definitely their first time in a museum. Seeing Islamic objects and culture in the museum had profound impact on the women and the community as a whole. The group work and sharing aspect of the project gave women immense self-confidence and an opportunity for personal development. The public recognition they were given from their community, especially the menfolk, empowered them to set up their own sewing classes and become more involved in the arts.'

GROUP LEADER

*Participants*

**Gulshan Aboobakar**

**Kausar Begum**

**Fatima Bharuchi**

**Saira Esmail**

**Lynda Freestone**

**Yasmin Hassan**

**Yasmin Khalifa**

**Roafa Khatri**

**Saida Khira**

**Nina Parmar**

**Rabia Raja**

**Amina Seeqat**

**Farida Sheikh**

**Farida Sidat**

*Group Leader & Artist*

**Deidre Figueiredo**

**Zed Sardar**

**Islamic Panel 2** *1992*

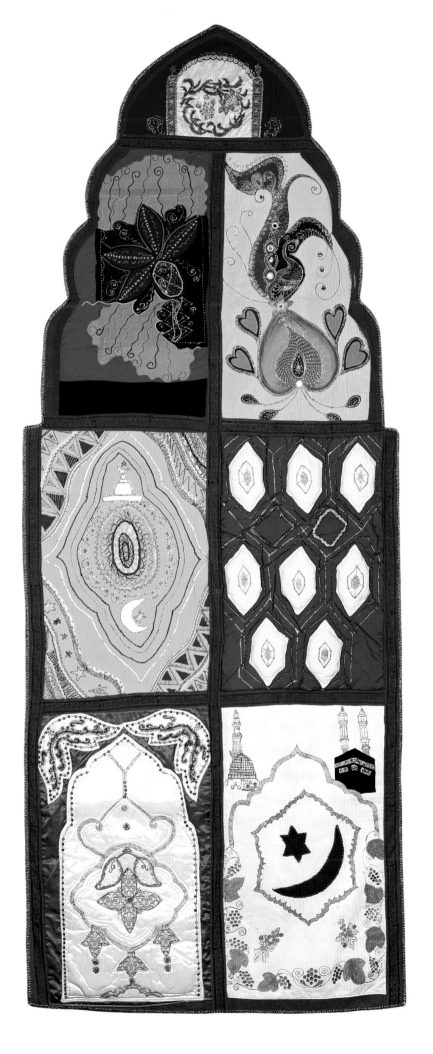

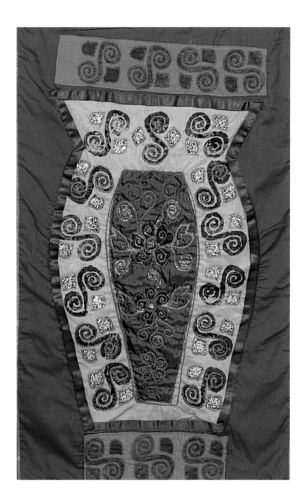

*'The group work and sharing aspect of the project gave women immense self-confidence and an opportunity for personal development.'*

**Islamic Panel 1** *1992*

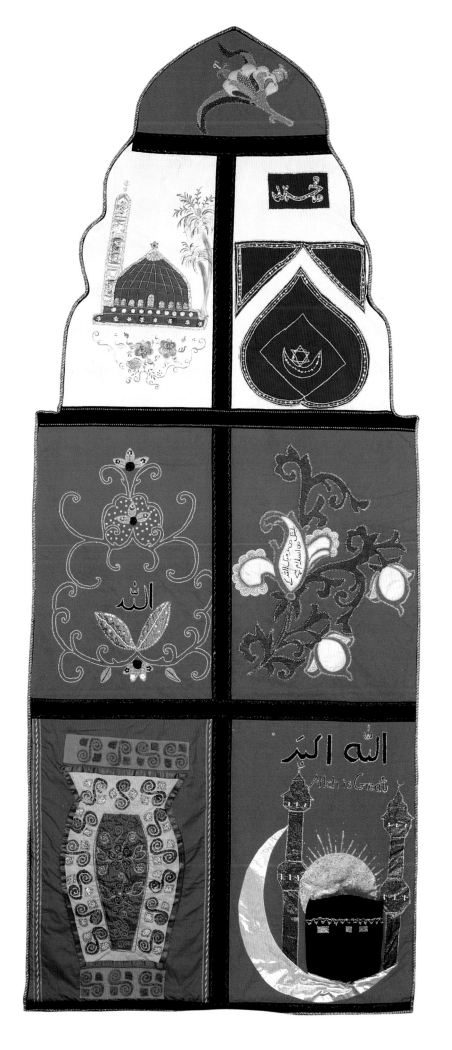

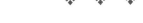

# Mirror Image · 1992

Mehfil-e-Tar
Bedford, Bedfordshire

'We talk together while we are working and it brings back memories of earlier times in our lives in distant lands.'

PARTICIPANT

*Participants*

**Shahnaz Akhtar**

**Yasmin Akhtar**

**Zaheda Amin**

**Manzoor Begum**

**Khateja Begum**

**Imtiaz Begum**

**Rukeea Begum**

**Razia Begum**

**Khalda Bi**

**Manzoor Bibi**

**Zaheda Bibi**

**Chhaya Bibi**

**Gulnehar Bibi**

**Fultara Bibi**

**Khadeja Iqbal**

**Nasim Khan**

**Asia Khatun**

**Razia Mahmood**

**Shanaz Majid**

**Zahaheda Parveen**

**Munawar Sultana**

*Group Leaders*

**Hameeda Awan**

**Jean Curtis**

**Sally Freer**

# Freedom for Life · 1993

Tower Hamlets Youth Group
Tower Hamlets College of Further Education, Tower Hamlets, London

'Our panel is of a woman symbolizing freedom.... We chose the colours according to their meaning in Islam: brown means roots and fertility; green is the colour of paradise and self assertion; yellow is powerful, it is the colour of the sun. The roots are holding her down, but her branches are blossoming at the top. She is breaking free from what is holding her back. The roots are trapping her. The symbols in the branches are of our freedom of choice. They are our rights as women: to education; to choose a career; to earn our money and be financially independent; to choose our own husband and the kind of marriage we want; to travel; to choose our own time to do things.

'We felt the book should be at the top because it symbolizes education. If you are educated you have more opportunities, more power. If you have education you can have all the others. We were influenced by the writing of Begum Rukia – an early twentieth-century Bengali Muslim woman who campaigned for the education of all Bengali Muslim women.'

GROUP STATEMENT

*Participants*

**Sofina Begum Ali**

**Razna Khatun Ali**

**Hasnara Khatun Ali**

**Ruksana Begum**

**Shamima Begum**

**Shapa Begum**

**Fateha Bibi**

**Rasia Bibi**

**Sultana Choudhury**

**Mariam Khatun**

**Runa Khatun**

**Latifa Miah**

**Quyen Thi Le**

**Mina Uddin**

*Group Leaders & Artist*

**Christine Barrow**

**Geraldine Bone**

**Melanie Jones**

**Sarbjit Natt**

**Georgie Wemyss**

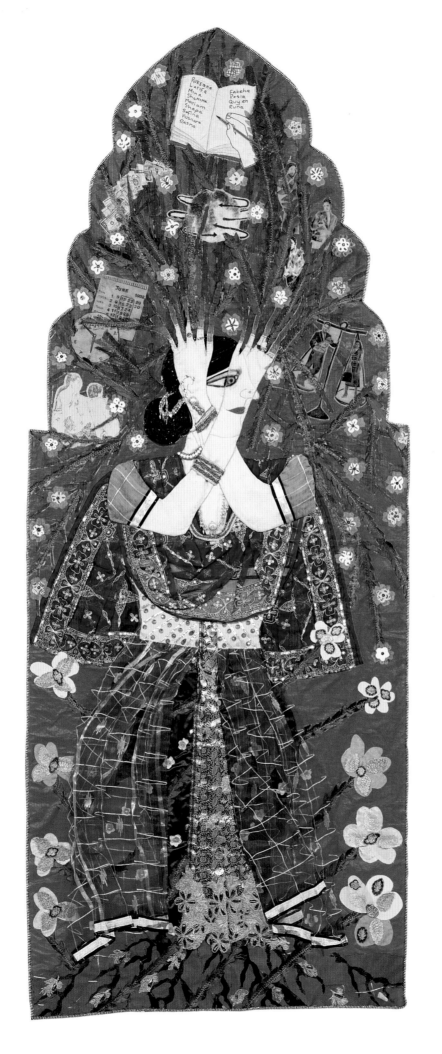

❖  ❖  ❖

# Ramadan/Eid Tree · 1993

Bethnal Green Primary Helpers' Group
and Jagonari Asian Women's Centre
Tower Hamlets, London

'We enjoyed the visit to the museum and learning about the Mughal period and Indian history. We would like to see more women visit the V&A as they have so many items from India and Bangladesh. Our panel tells the story of our life during the month of Ramadan, which is a month of fasting for self-purification. It is one of the Five Pillars of Islam, which every Muslim should practise. It is followed by the festival of Eid, which celebrates the end of fasting period indicated by the sighting of the moon. We have chosen to represent Ramadan and Eid through hand gestures praying; putting henna on hands; offering dates on a plate to open each day's fast at sunset; shaking of hands, a gesture representing the moment people embrace and wish each other a happy Eid – *Eid Mubarak*. We took the image of the Tree of Life from examples we saw in the Nehru Gallery and branches growing on each side containing a symbol of either Ramadan or Eid. We have chosen the colours for their Islamic significance: brown for fertility; green for paradise and because it is the colour of the Prophet Muhammad's cloak; orange for devotion; white for peace and purity. Other meanings are green for plants and trees, orange for the colour of the sun and brown is the colour of our skin.

'It's been good to work in a group and learn different stitches from each other. We have enjoyed working on the panel together and we also feel that visiting the museum is no longer a favour that has been bestowed upon us; we consider it our right to make subsequent visits.'

GROUP STATEMENT

*Participants*

**Hasna Begum**

**Shahina Begum**

**Syeda Bilkis Begum**

**Momotaz Begum**

**Fatima Begum**

**Rehana Begum**

**Rashna Begum**

**Shahina Begum**

**Asma Bibi**

**Nurasa Bibi**

**Johanara Bibi**

**Sultana Chowdhury**

**Shamsun N. Khanom**

**Rina Khatun**

**Hasna Khatun**

**Rezia Khatun**

**Shirina Khatun**

**Shamsun Nehar**

**Mayarun Nessa**

*Group Leaders & Artists*

**Roshanara Begum**

**Maryam Begum Rob**

**Roshan Khan**

**Geraldine Bone**

**Fahmida Shah**

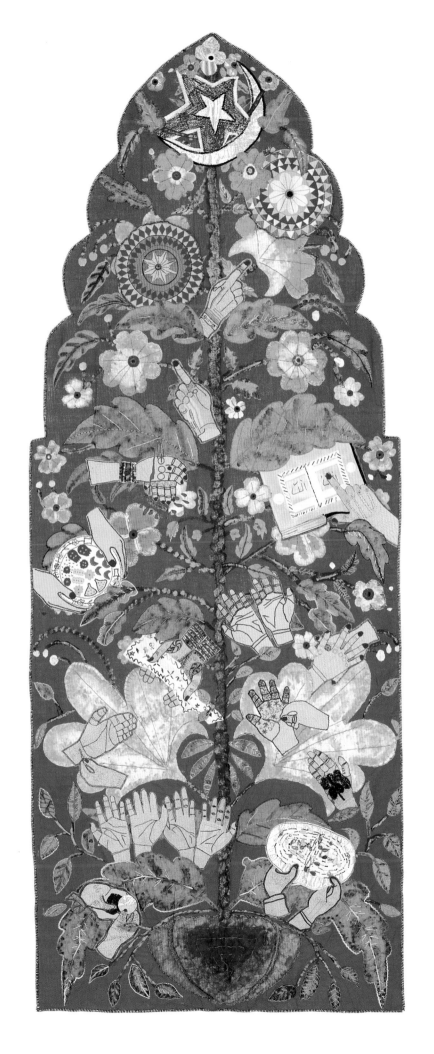

❖   ❖   ❖

# Geometric Unity · 1993

Bryony Women's Centre Asian Youth Project &
Sweet Union School Ethnic Minorities Project
Hammersmith and Fulham, London

'Unity was at the heart of our design, which represents all of us from different backgrounds living and growing together. This project has helped us to build a better understanding of each other and find peace among us.'

PARTICIPANT

'At first it was discussed formally whether we wanted to do this panel or not. I was quite interested on hearing the prospect of doing the panel with silk-screen printing, *shisha* work and embroidery. When we first started, we did some stencil-making and silk-screen printing, which was new for me and good fun. This made me more interested in completing the panel so that I could see what it would look like when finished. The following week after starting the embroidery, I felt my enthusiasm diminish at the thought of how much work was needed to be done and all the stitch-work required. After a few more sessions the panel looked full and I felt quite happy because everybody's work had been put on to it and it was looking good. I thought it rather rewarding to have it put up as a display in our centre for others to see. I'm anxious to know what others think about it. I think this project has inspired me to go forward into the arts.'

PARTICIPANT

| Participants | Group Leaders & Artists |
|---|---|
| **Saeeda Abasi** | **Meena Jafarey** |
| **Shawla Ahad** | **Caroline Jenkins** |
| **Rahma Ahmed** | **Imrana Khan** |
| **Fahima Ahmed** | **Amanda Webb** |
| **Sabina Ahmed** | |
| **Jahura Begum** | |
| **Anwara Begum** | |
| **Shipa Elas** | |
| **Mahmuda Elas** | |
| **Kidisti Habte** | |
| **Aisha Kadir** | |
| **Khadkinja Khan** | |
| **Khan Begum Khan** | |
| **Afzia Khawaja** | |
| **Aadam Khwaja** | |
| **Raquyah Khwaja** | |
| **Bilal Khwaja** | |
| **Tayyeaba Khwaja** | |
| **Amna Khwaja** | |
| **Safiyah Khwaja** | |
| **Fatima Muhammad** | |
| **Bushra Qureshi** | |
| **Saeedah Qureshi** | |
| **Samina Qureshi** | |
| **Riffat Rahman** | |
| **Naima Rahman** | |
| **Vani Rajkumar** | |
| **Sarah Sayeed** | |
| **Sheela Surinder** | |
| **Kadan Tekle** | |
| **Fakadu Zeggai** | |

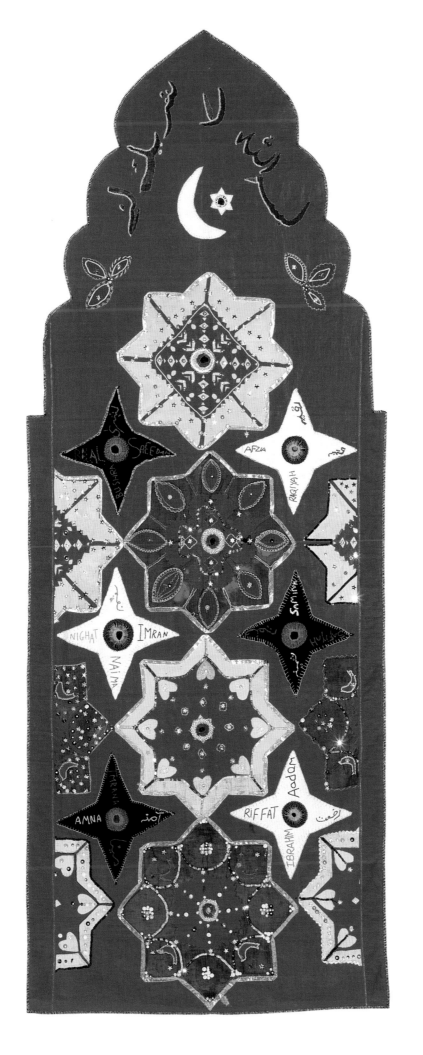

❖　❖　❖

# Traditions · 1993

Burdett Eagles Girls' Group
Poplar, London

'The anticipation and excitement of a marriage ceremony also brings responsibilities and taking on a new role. We think about this as we see our friends getting married, especially as we know it could be our turn next.'

GROUP STATEMENT

*Participants*

**Aysha Begum**

**Dilara Begum**

**Fatema Begum**

**Nazira Begum**

**Rubina Begum**

**Runa Begum**

**Rukshana Begum**

**Sherina Begum**

**Shelina Begum**

**Annie Choudhury**

**Manni Choudhury**

**Tanni Choudhury**

**Apipa Khanum**

**Yasmin Nilafar**

*Group Leader & Artist*

**Shahana Choudhury**

**Sarbjit Natt**

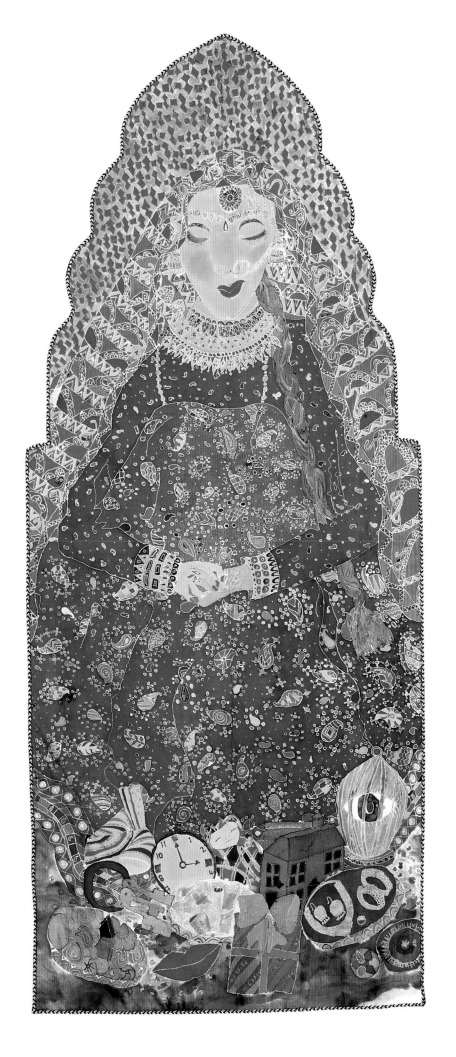

❖  ❖  ❖

# Peacock · 1993

Foundation Art Group
Tower Hamlets College of Further Education
Tower Hamlets, London

'The group who created *Peacock* were full-time ESOL [English for Speakers of Other Languages] students at Tower Hamlets College who chose the optional Art class. This meant that as well as the young women from Bangladesh, Vietnam, Somalia and Iran, there were two young Bangladeshi men in the group as well.

'Everyone had different skills and insights to add to the process of creation. Dulu liked the idea of the peacock as a central motif and was able to move the rest of the group to make a decision. Nazma had been especially inspired by the fine chain-stitching in the Mughal hangings at the V&A and hand-embroidered the yellow corner symbols. Luthfa had an overall vision of what the panel should look like and spent hours embroidering leaves and stitching beads in place. Soyful withstood good-natured teasing and jokes to do some serious stitching. Alea brought joy and enthusiasm to the whole experience. Thi Hoai ensured that discussions on Asia included Vietnam and Asha added Somali perspectives to the project. Sayeh used her knowledge of Farsi to read the ancient Persian in the Akbarnama and bring home to everyone the historical links that bind us together.

'Each student involved took home a square of yellow or blue silk and a handful of mirrors, glass beads and embroidery silk. Members of extended families therefore became involved; some of the stitching was done by those in the class, others less confident convinced someone else at home to do it. Each returned with an individual interpretation of the peacock feather, which was then sewn on to the body of the bird.

'As well as its obvious beauty and association with Mughal India, the peacock symbolized yearning for something far away. The Muslim students commented on how they used the feathers in the Quran to mark a particular page. The moon and stars were important as symbols of Islam and because of the unity they inspire. Wherever we are in the world, we can see them and think of others looking at them too.'

GROUP STATEMENT

*Participants*

**Sayeh Bayet**

**Jahanara Begum**

**Mahmuda Begum**

**Luthfa Begum**

**Noorjahan Begum**

**Sultana Begum**

**Nazma Bibi**

**Momtaj Bibi**

**Asha Botum**

**Thi Hoai**

**Soyful Islam**

**Sheley Jahanara**

**Alea Khatun**

**Morshed Miah**

**Dulu Nessa**

*Group Leaders & Artists*

**Geraldine Bone**

**Sarah Hammond**

**Imrana Khanum**

**Georgie Wemyss**

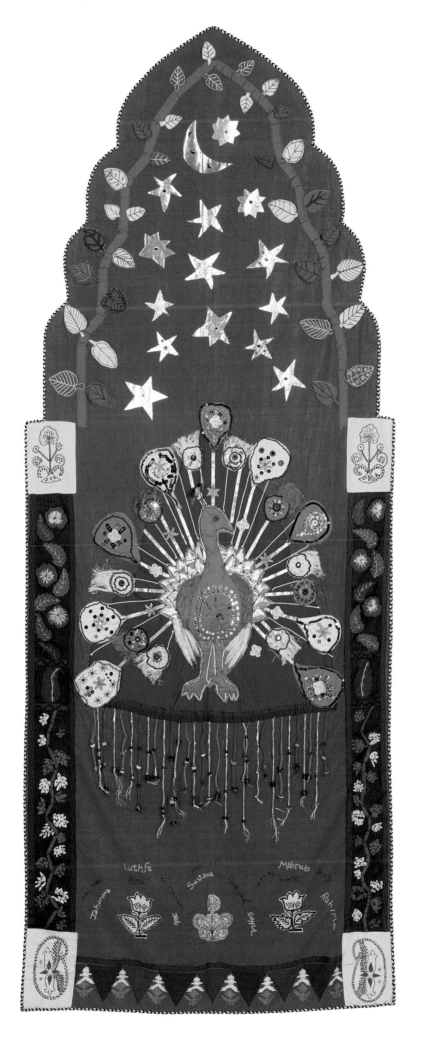

❖  ❖  ❖

# Two Landscapes · 1993

Ansford Community School
& Members of Castle Cary and Ansford Community
Somerset

'Two of us felt that as we were in Somerset our panel ought to portray some local theme. We then began to focus on the landscapes portrayed in the Mughal court paintings – pictures of beautiful pools full of waterlilies. From this came the unifying theme – "water". Castle Cary and Ansford are on the edge of the Somerset levels where water is quite an issue: to drain or not to drain! Between us we decided that our panel should consist of two mihrab-shaped arches through which could be glimpsed two landscapes – an Indian one and a Somerset one with a Tree of Life in the middle. On the Somerset side a river would flow down from Glastonbury Tor (a local landmark of historical and religious importance), into the Indian side, where it would become a beautiful pool full of waterlilies.

'...Our panel shows two landscapes from India and Somerset, representing two different cultures united by a common theme – "water". The nourishing Tree of Life is fed by water it draws from both cultures.'

GROUP LEADER

*Participants*

**Ann Bailey**

**Ann Bertalot**

**Gabrielle Davies**

**Teresa Foster**

**Laura O'Gorman**

**Christine Hellings**

**Pat Jones**

**Claire Kingston**

**Rosie Phelps**

**Joyce Trikilis**

*School Co-ordinators &
Group Leader*

**Lydie Gardner**

**Lin Hawkins**

**Laura Tillings**

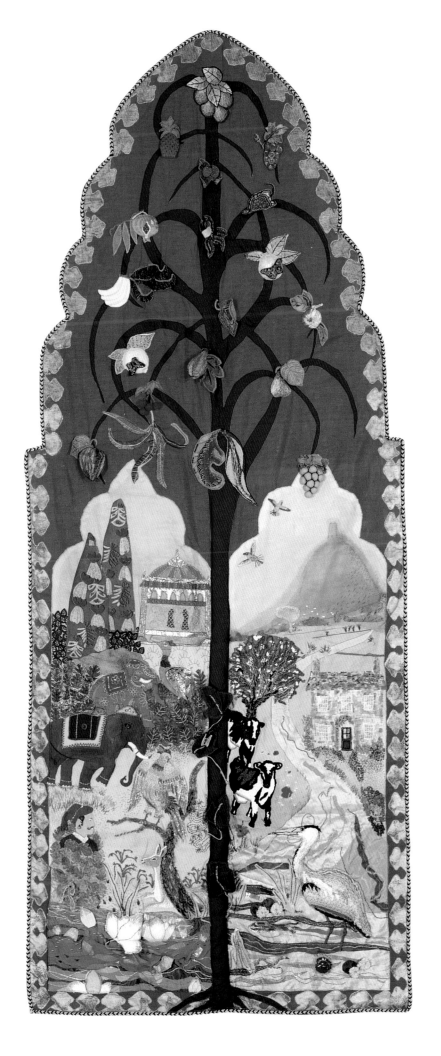

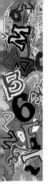

❖ ❖ ❖

# The Tree of Knowledge · 1993

City Challenge Language 2000 Group
Tower Hamlets, London

'I did the body of the tree, a mango and a cheque; I did a lot more but these are of the ones showing a meaning, for example, the cheque shows giving money to relatives in Bangladesh, and in Bangladesh we have a lot of mango trees.'

PARTICIPANT

'Our tutor, Sarbjit, encouraged us to use our own ideas and draw everyday things – vegetables, fruits, trees, jewellery, etc. We wanted our tree to be a Tree of Learning, showing the learning we have done in Bangladesh and England – there are letters of the alphabet from both the languages on the panel. I helped to explain to the women what we were aiming to do. It was hard at first because the women hadn't been given the chance to explore their own ideas before. I was able to help explain because of my experience the year before of having worked on the Eid panel (with another group). I have enjoyed it so much I feel as though I had done a good job because I knew the end result would be worth all the hard work. Now I am looking forward to seeing the panel in the V&A Museum because I will feel so proud when everyone is looking at the panel and admiring it. I would like to get more involved in projects like these.'

GROUP LEADER

*Participants*

**Aleya Begum**

**Rupia Begum**

**Fulmala Bibi**

**Saif Bibi**

**Hena Khan**

**Khoyrun Nessa**

**Nazma Parvin**

*Group Leader & Artist*

**Mayarun Nessa**

**Sarbjit Natt**

# Reflection of Harmony · 1993

Ethnic Minority Centre
Mitcham, Surrey

'Our community centre is used by women and their families from different religions and cultures. We wanted our panel to reflect people of different religions living together in harmony and with respect for each other.'

GROUP LEADER

*Participants*

**Fazilat Ahmed**

**Ishrat Ahmed**

**Neaz Ahmed**

**S. Ali**

**Shibani Basu**

**Rabia Begum**

**Dr Biswas**

**Sunita Chatterjee**

**Sunaya Choudhry**

**Farzana Chowdhry**

**Lina Datt**

**Nazim Ghauri**

**Shabnam Ghosh**

**Nasreen Hassan**

**Dr Aneena Hussain**

**Yasmin Hussain**

**Amita Hussain**

**Rina Islam**

**Lakhminder Jagdeu**

**Husne Jahan Molla**

**Afroza Jamal**

**Gian Kaur**

**Tanya Khan**

**Farzana Khan**

**Tasneem Khan**

**Yasmin Khan**

**Anjum Kiduai**

**Shahnaz Latif**

**Nahrein Mirza**

**Faizal Mirza**

**Siraed Mohamad**

**Pingla Naidoo**

**Pashma Rahman**

**D. Rahman**

**Hafiza Rahman**

**Sabitri Ray**

**Dipu Roy**

**Santosh Sahdeu**

**Padmini Samarasekera**

**Shuaib Sheikh**

**Pauline D'Silva**

**Noor Sultana**

**Kiran Thakkar**

**Mel Thomas**

**Rosemary Turner**

**Dotty Wanigesekera**

**Ravini Wanigesekara**

**Naila Zafar**

**Firdosi Zaman**

*Group Leaders & Artist*

**Lilly Khan**

**Razia Killeadar**

**Tasneem Mohammadally**

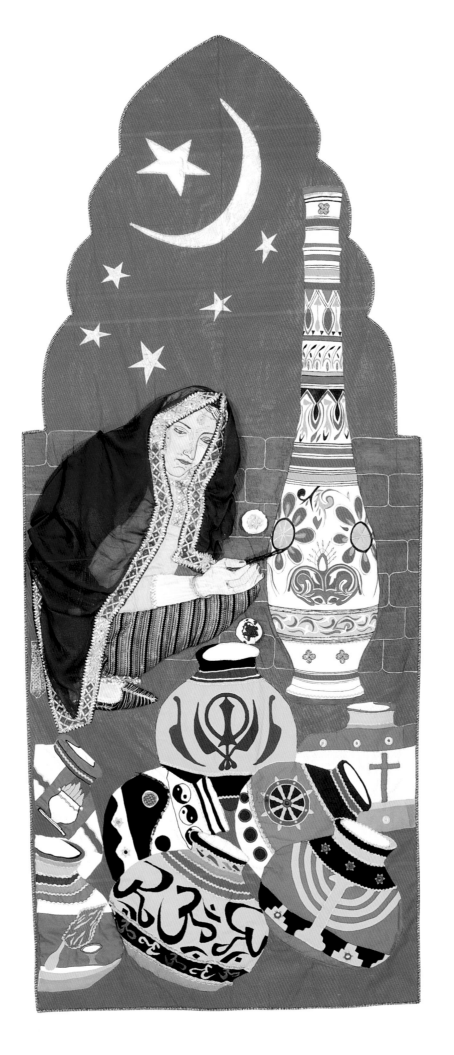

# The Dance of Life · 1993

West Tallaght Women's Textile Group
Dublin, Republic of Ireland

'We chose to keep our designs along the same lines as the miniatures and to adopt the two dancers as our central figures – one in an Indian costume and the other in Irish, hand-in-hand celebrating their own cultures...

'The project began with a group of Irish women only and later was joined by three South Asian women. The group enjoyed having an outside element coming into the group. It challenged their preconceptions of Asian women and it was refreshing to hear other aspects; other ways of working. It was also felt it was a pity that they didn't work with the group from the start of the project.

'The women have chosen to represent themselves, around the central figures, in the activities they found the most creatively satisfying. They also wanted to portray themselves at their most confident dress-wise – this was either fantasy or reality....

'**Christine** – opera dress, knitting, a phoenix and a fish as her symbol...**Dorothy** – knitting, wearing her kafta...**Bernie** – ballerina, reading with the scales of justice...**Jilloo** – in her sari, defiant against her husband...**Lillian** – pregnant in her Sunday best ... letting her thoughts wander like a butterfly...**Marion** – in her Shirley Bassey outfit ... Marion was a cabaret singer and puts her heart into her writing ...**Promilla** – sketching in her chemise...**Catherine** – an open window symbolizes her freedom... **Donna** – in her best clothes, gardening the Tree of Life. Donna is very conscious of her children – their growing up...**Wendy** – taking a break from art in a circus outfit. The tiger is how she felt within the centre after they asked us to leave – stalking but ready to pounce if necessary...**June** – sketching in her most comfortable outfit....'

GROUP LEADER

---

*Participants*

**June O'Conner**

**Lillian Dalton**

**Marion Kilbey**

**Donna Kilbey**

**Christine Mason**

**Bernie McCarville**

**Dorothy Pereira**

**Jilloo Rajan**

**Promilla Shaw**

**Catherine Walker**

*Group Leader*

**Wendy Cohan**

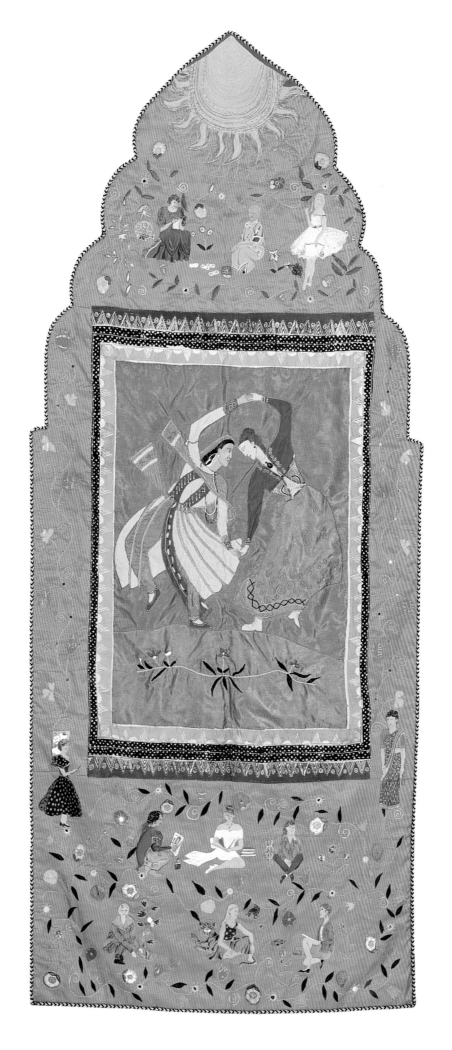

❖　❖　❖

# Freedom · 1993

Stepney Girls' Group
Tower Hamlets, London

'We looked at our ambitions and hopes for the future as young Muslim girls. The recurring theme was "freedom" and its opposite "trapped". Looking at the symbolism in Islamic art we devised our own symbols of freedom: birds in flight; Tree of Life; water and rainbows. We did some paintings of emotions – love, hate, anger, peace, freedom and trapped. We put our "freedom" symbols on to our freedom painting and then "trapped" them with *jalis* [lattice screens] like the ones in the Nehru Gallery. The colours we chose also have Islamic significance: blue is the colour of peace and high ideals; yellow is for power – the colour of the sun; green is a holy colour and also means superior attainment and purple expresses the determination to make dreams come true.'

GROUP STATEMENT

*Participants*

**Ruby Barha**

**Runa Barha**

**Farida Begum**

**Jorna Begum**

**Rajia Begum**

**Resna Begum**

**Ruzi Bibi**

**Asma Khanam**

**Tofura Khanum**

*Group Leaders & Artists*

**Christine Barrow**

**Geraldine Bone**

**Yasmin Qureshi**

**Fahmida Shah**

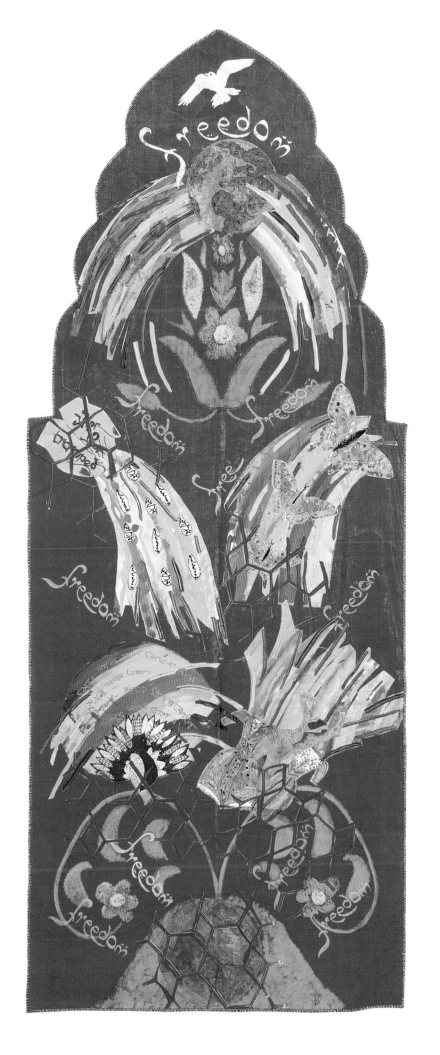

❖  ❖  ❖

# Pot of Life · 1993

Aston Hall Asian Women's Textile Group

Co-ordinated by Birmingham Museum and Art Gallery

Aston, Birmingham

*Participants*

**Balbir Bajway**

**Naina Barot**

**Ila Bhatt**

**Sulochana Bhatt**

**Satpal Kaur Bhogal**

**Rama Chandegra**

**Sanita Kalyana**

**Paramjit Kaur**

**Masooda Kazi**

**Fatima Mukadam**

**Parvin Padham**

**Sarla Parmar**

**Pani Vara**

**Rama Vara**

**Shanta Vara**

*Group Leaders*

**Balbir Kaur Nazran**

**Eleanor Viegas**

'Islamic tile mosaics in the Nehru Gallery inspired the women to work on the design. The final design was based on a traditional Islamic tile decoration showing an urn of plants trailing over a flat surface. The design was first drawn out to the actual size of the hanging. A tracing was made of the design and then this was cut up into sections. The design on each section was transferred on to the fabric. Each member of the group worked on an individual section choosing their own colour and stitches. The women did such wonderful work without even studying colours, but just working directly on the piece the way they used to back home. They would never hesitate if they made a mistake or did not like the colour they had chosen; they would simply unpick the threads and start again. The embroidered pieces were reassembled leaving a small space between each section to give the appearance of a tile mosaic when seen from a distance.

'This panel represents all of us working in friendship and unity, beginning here as seeds in the pot, growing and spreading. As we grow stronger, the plants become more colourful and the blossoms show new life.'

GROUP LEADER

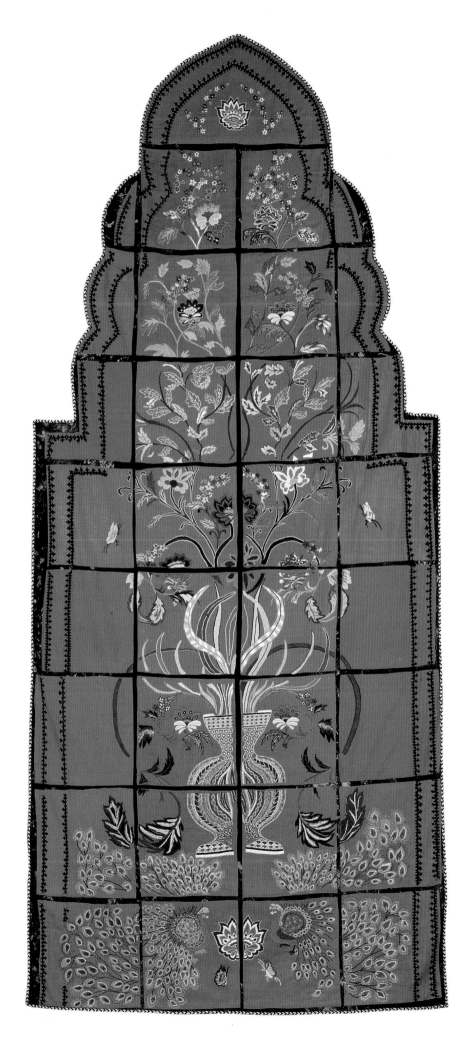

❖ ❖ ❖

# Tapestries of Life · 1993

Madras Craft Foundation
Madras, India

'Each group was given a sample of the panel cut-out and they were instructed to sketch details of their general lifestyles and ideas they would like to represent about themselves. The Yellammathanda Group immediately set about using the outer frame of the panel as a doorway with the Banjara women in front of it. The [Lambadis] women from Sandur merely indicated that they would work out designs with the different embroidery stitches known to them. Like the [Lambadis] women… the Todas [women from Nilgiris] were also uncomfortable with the idea of working on designs that represented aspects of their culture and lifestyle. The embroidery of the Todas [women] resembles abstract geometric figures and has certain meanings associated with each, but which is not visually comprehensible to outsiders.

'Once each group decided on a particular format, they began to work leisurely. Their work was accompanied with lively songs. The visitors to the museum were entertained with the songs, which covered varied topics from their visit to Madras, to their first impressions of the place and people, Rajiv Gandhi's assassination and songs of Nature, etc.

'Each group worked on a single panel of their own and also worked on sections of the main panel which was a combined effort.'

GROUP CO-ORDINATOR

*Participants*

**Lambadis women from Sandur (*Karnataka*)**

**Todas women from Nilgiris (*Tamil Nadu*)**

**Yellammathanda Group (*Andhra Pradesh*)**

*Group Co-ordinator & Artist*

**V.R. Devika**

**Kalyani Pramod**

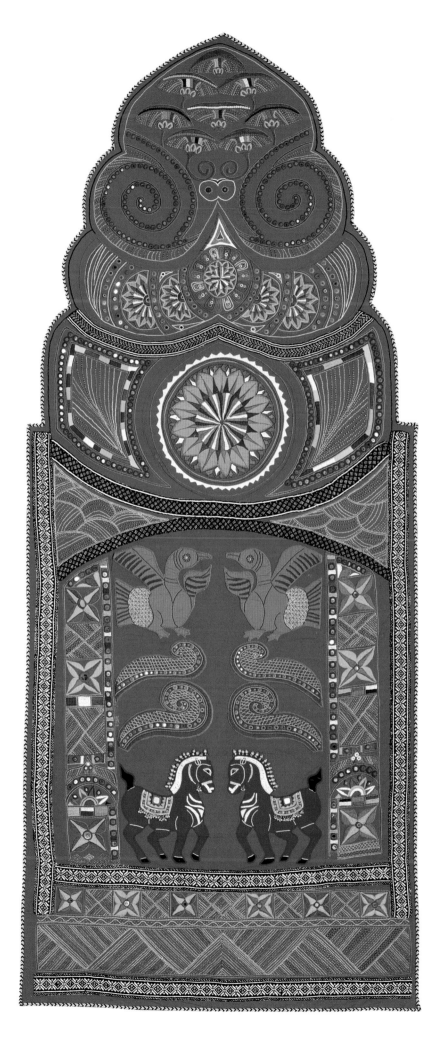

# Unity · 1994

Bengali Women's Group and Bengali Girls' Group
Camden, London

'Detailed discussion took place as to the different aspects of design work on the basis of the group experience from visiting the V&A. We also discussed the theme of the project – the "Tree of Life", the "peacock" or a "portrait of Noorjehan". Various other ideas cropped up, particularly the images of the mosque as it plays an important role in a Muslim's life not only in their religious life but also in educational and cultural life as well. The women were impressed by the art of Arabic calligraphy and expressed their interest to include Arabic verse in the panel…. One woman brought a beautiful card with an Arabic inscription, which says: "In God's name we all come together."

'After much discussion it was decided that the panel would have the image of a mosque with two decorated pillars at the sides. The Arabic inscription was included with some scattered flowers and the design would be drawn from women's drawings.

'One woman suggested that in the middle of the panel we could create an image of a group of women [seen] from the back (as the women did not like the drawings of any kind of figures) and we could name our panel as *Unity*, as this is the most important thing that we have to maintain if we want to improve our position.

'The tutor helped the group to accommodate all the ideas into the template and a sketch of the final design was finally drawn. The women were gradually getting more enthusiastic about creating a panel of their own. On the basis of the sketch drawn in the earlier session, the work of the project began with women creating flower motifs on velvet materials. The Women's Group carried out the work in the centre of the panel whilst the Girls' Group mainly carried out the embroidery work on the two pillars….'

GROUP LEADER

## Participants

**Rabeya Ahad**

**Ruzina Aklan**

**Nazima Aktar**

**Asma Begum**

**Lubna Begum**

**Runa Begum**

**Robin Begum**

**Rupsana Begum**

**Sona Bibi**

**Sapna Bibi**

**Helen Khan**

**Razia Khanom**

**Joly Khanom**

**Rina Khanom**

## Group Leaders & Artists

**Linda Ball**

**Asmin Chowdhury**

**Sophia Khan**

**Marion Wasser**

**Kawser Zannath**

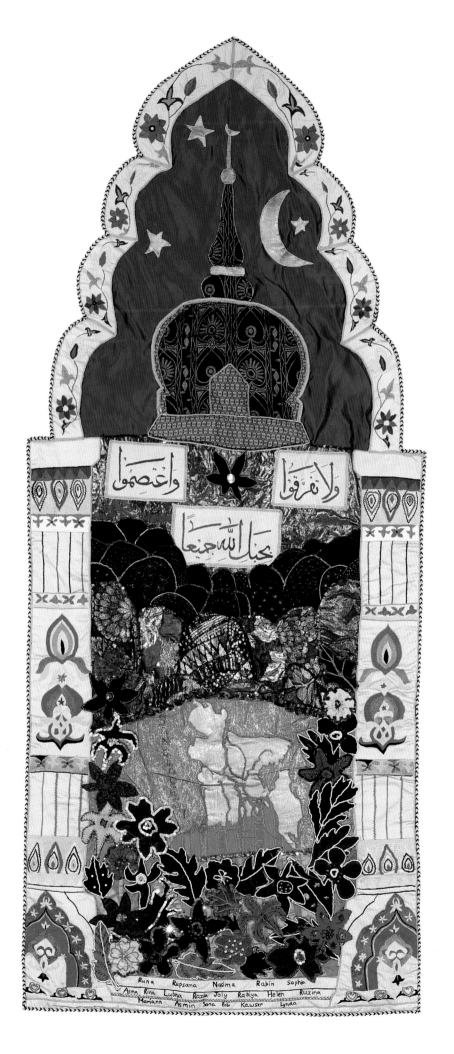

ولا تفرقوا واعتصموا

بحبل الله جميعا

Runa    Rupsana    Nasima    Rabin    Sophia
Asma  Rina  Lubna   Razia  Joly   Rabiya  Helen   Ruzina
Mariam    Asmin  Sona  Bibi  Kawser   Lynda

# Food for Life · 1994

Sir John Cass Foundation Primary School &
Blue Gate Fields Infant School (Parents and Children)
Tower Hamlets, London

'We encouraged this project in order to form a partnership to extend and link the use of the Parents' Room at both schools. We also wished to highlight talents of parents in our schools and to provide a medium through which to channel those talents to the next generation. The age range of participants of the panel covered over sixty years, the youngest being only three years old.

'The theme "Food for Life" was chosen because the provision of food for our families is a universal daily task for women, regardless of their colour, faith, age, class or ability. In creating the panel we celebrated the rich cultural heritage of the children in our schools.'

SCHOOL CO-ORDINATORS

Participants

SIR JOHN CASS FOUNDATION PRIMARY SCHOOL PARENTS AND STAFF:

**Shahida Ahmed**
**Rabia Begum**
**Shafa Begum**
**Shaheeda Begum**
**Frances Ross Duncan**
**Mina Kolil**
**Jean Langley**
**Sufia Mahmood**
**Jill McGinley**
**Touriya el Meeyuf**
**Somirun Nessa**
**Julia Okyere**
**Hasna Rahman**
**Rahena Rahman**
**Hasna Rashid**
**Edna Russell**
**Dalila Ait Said**
**Diana Stoker**

SIR JOHN CASS FOUNDATION PRIMARY SCHOOL CHILDREN:

**Kaysar Ahmed**
**Tamanna Akhtar**
**Forid Alom**
**Sabir Barigou**
**Rumi Begum**
**Shahena Begum**
**Angura Begum**
**Alex Gilbody**
**Shahanara Hussain**
**Wayne Phidd**
**Bradley Richards**
**Raziha Sultana**
**Faithlyn Duncan Whittle**
**Nily Yeasmin**

BLUE GATE FIELDS INFANT SCHOOL PARENTS AND STAFF:

**Farzana Akhtar**
**Rina Begum**
**Sufia Begum**
**Parvin Begum**
**Halima Begum**

**Suhela Begum**
**Sabiha Begum**
**Jayeeta Bhomick**
**Mashuk Bibi**
**Sujan Bibi**
**Emma Hudson**
**Rahima Khatun Rani**
**Josie Lock**
**Maureen McGrath**
**Sue Miles Pearson**
**Azizur Nessa**
**Laila Nessa**
**Jaheda Rahman**
**Saleha Rahman**
**Rosie Walker**
**Poppie Wright**

BLUE GATE FIELDS INFANT SCHOOL CHILDREN:

**Foysal Ahmed**
**Khalid Ahmed**
**Jubel Ahmed**
**Farjana Bahar**
**Shamima Begum**
**Rizni Begum**
**Rahima Begum**
**Salima Begum**
**Salma Begum**
**Rujee Begum**
**Rubi Begum Miah**
**Boshra Chibou**
**Mojammil Hussain**
**Imran Khan**
**Rukiya Khatun**
**Ayesha Khatun**
**Najmah Khatun**
**Bobbie Lee**
**Abdul Majid**
**Moinul Miah**
**Abdul Rahim**
**Rjina Sultan**

School Co-ordinators

**Jeba Rahman Alom**
**Deepa Bhattacharjee**
**Michele Rowe**
**Linda Yon**

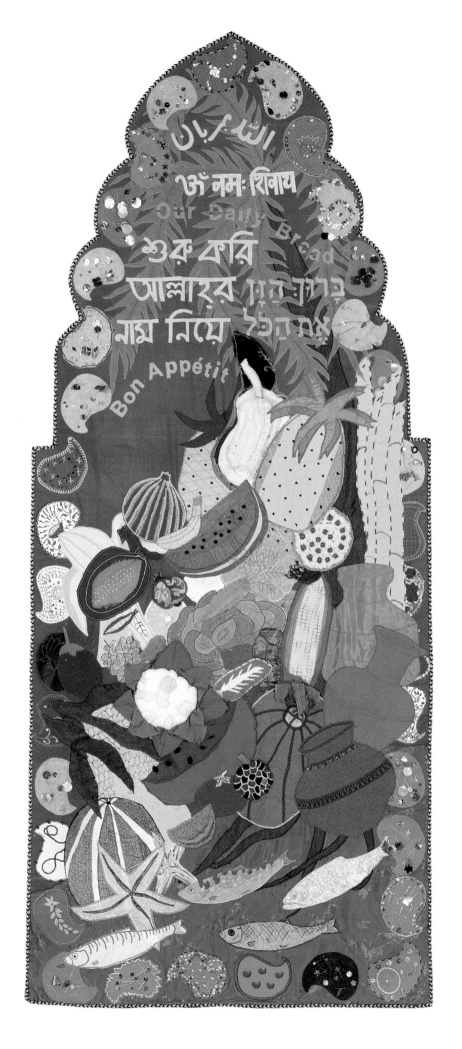

❖  ❖  ❖

# Arcadia 1994

Sadaf Women's Group
Co-ordinated by
Mid Pennine Arts, Burnley,
Lancashire

# Nowhere to Run · 1994

Kanwal Girls' Group
Co-ordinated by
Mid Pennine Arts, Burnley,
Lancashire

'These two panels were made at the same community centre and were designed to hang together in the centre when they return from the V&A. The Sadaf women had only one proviso – they wished to do something which featured animals. "Noah's Ark" was suggested as a theme and was accepted. The fact that this and other *Old Testament* stories were held in common by both Muslims and Christians was a bonus.

'... As *Arcadia* progressed, and the girls hanging, *Nowhere to Run* was being evolved; they were seen to make a complementary pair loosely connected by the idea of war and peace or at least God's forgiveness. One features Mount Ararat, the other the Mountains of Sarajevo. They are also connected by their use of borders and the complementary colour.

'The Kanwal Group's piece became about the destruction of civilization and culture of agents of war – represented by guns, helicopters and explosions and flames featured in the border as well as the main panel. Images came from media and reference books. Culture is represented by pots on the right side of the hanging, one of which is broken. The small mihrab shapes contain representations of families, peace, agriculture and food. The bottom sections represent the broken remnants and the debris of war with the whirlpool sucking lost security into its depths.

GROUP LEADER

Nowhere to Run
*Participants*

**Jayna Begum**

**Jusna Begum**

**Mumtaz Begum**

**Najma Begum**

**Sabia Begum**

**Shabana Begum**

**Shefa Begum**

**Nasreen Hassan**

**Kuky Jalil**

**Hinna Janjua**

**Laila Khan**

**Lubria Khan**

**Rana Khanom**

**Jahanara Khatun**

**Rehanara Khatun**

**Soyedun Nessa**

**Yarun Nessa**

**Rubia Parveen**

**Farzana Qader**

**Abida Rafique**

**Anwara Shahid**

Arcadia *Participants*

**Samir Azad**

**Elaine Sagar**

**Farhat**

**Saide**

**Sughara**

**Thiare**

*Group Leader & Artist*

**Liz Rayton**

**Jacky Riddell**

**Arcadia** *1994*

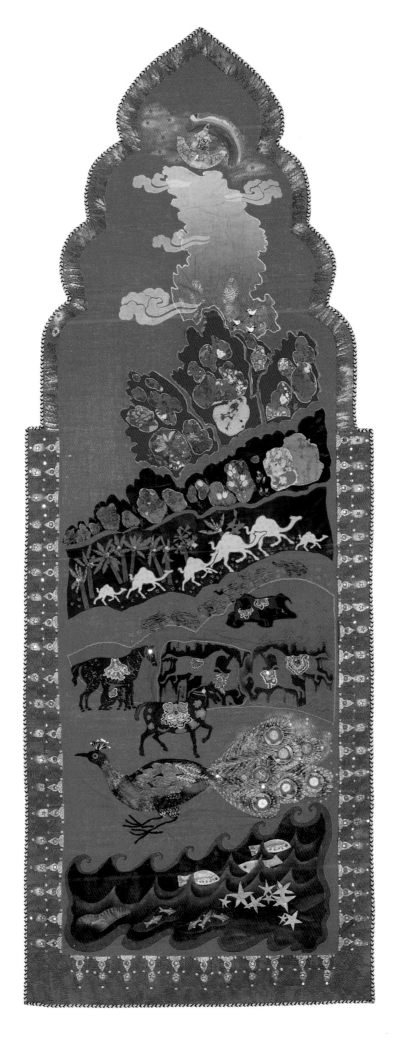

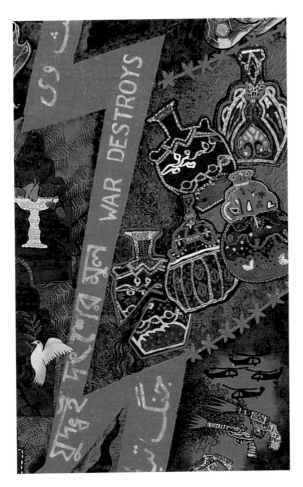

*'Culture is represented by pots on the right side of the hanging, one of which is broken. The small mihrab shapes contain representations of families, peace, agriculture and food.'*

**Nowhere to Run** *1994*

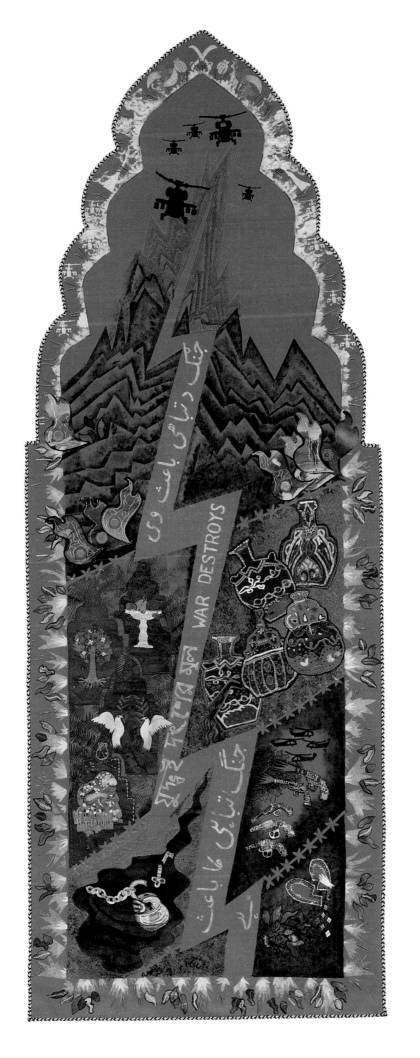

❖  ❖  ❖

# Mother and Child
## 1994

Ethnic Minority Centre
Mitcham, Surrey

'Becoming a mother is a happy event in a woman's life. We wanted this panel to show the importance given to motherhood in the Asian culture.'

GROUP LEADER

*Participants*

Fazilat Ahmed

Ishrat Ahmed

Neaz Ahmed

S. Ali

Shibani Basu

Rabia Begum

Dr Biswas

Sunita Chatterjee

Sunaya Choudhry

Farzana Chowdhry

Lina Datt

Nazim Ghauri

Shabnam Ghosh

Nasreen Hassan

Dr Aneena Hussain

Yasmin Hussain

Amita Hussain

Rina Islam

Lakhminder Jagdeu

Husne Jahan Molla

Afroza Jamal

Gian Kaur

Tanya Khan

Farzana Khan

Tasneem Khan

Yasmin Khan

Anjum Kiduai

Shahnaz Latif

Nahrein Mirza

Faizal Mirza

Siraed Mohamad

Pingla Naidoo

Pashma Rahman

D. Rahman

Hafiza Rahman

Sabitri Ray

Dipu Roy

Santosh Sahdeu

Padmini Samarasekera

Shuaib Sheikh

Pauline D'Silva

Noor Sultana

Kiran Thakkar

Mel Thomas

Rosemary Turner

Dotty Wanigesekera

Ravini Wanigesekara

Naila Zafar

Firdosi Zaman

*Group Leaders & Artist*

Lilly Khan

Razia Killeadar

Tasneem Mohammadally

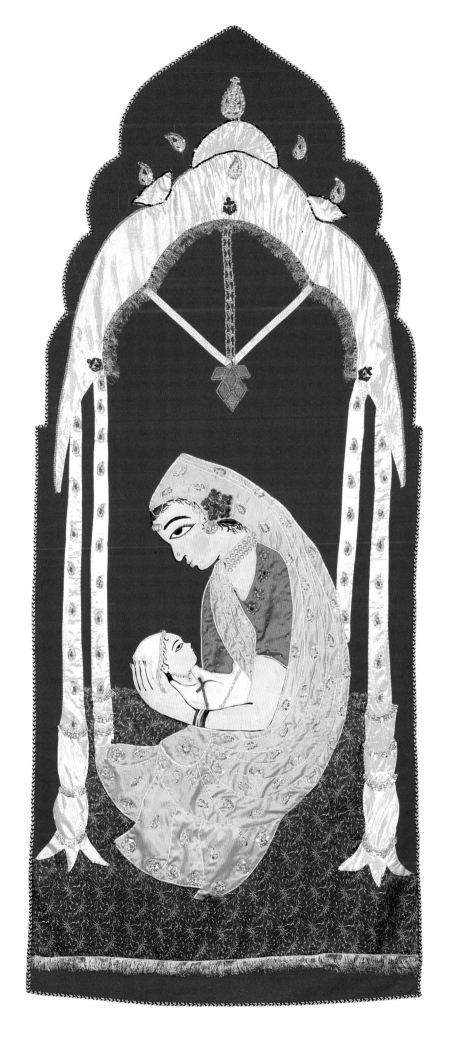

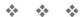

❖  ❖  ❖

# Asian Women in Action · 1994

Audley Asian Women's Group
Co-ordinated by Blackburn Museum and Art Gallery
Blackburn, Lancashire

'The opportunity to participate in the Mughal Tent Project was very important to us in Blackburn. The town has a large Asian population – some fifteen per cent of the total. Some of them have lived here for many years, having come originally during the long lost days of prosperity in the textile industry. Many people came from the State of Gujarat in India, or from neighbouring areas in Pakistan.

'During the past decade Blackburn Borough Council has sought to recognize and celebrate the culture of this part of its population, appointing a South Asian Arts Development Officer and creating a South Asian Gallery, devoted to the history, culture, arts and crafts of the subcontinent, in the Blackburn Museum and Art Gallery. However, opportunities for members of the Asian community, especially women, to participate actively in the developments of art and culture were very limited. The chance to take part in the Mughal Tent Project did not only provide an opportunity for joint creative activity, it also set that activity in a national, indeed an international, context.

'The Audley Asian Women in Action received technical help from our local community arts team, Action Factory, but the work and the ideas were their own.... The finished panel, together with those created in neighbouring Burnley, were exhibited here in the South Asian Gallery, and in Burnley and Clitheroe, before going to London for the opening at the V&A. That the work of Asian women should represent Blackburn on such an exalted occasion was a source of great pride to us all.'

GROUP LEADER

*Participants*

**Mariam Chothia**

**Fatima Hussein**

**Hamida Hussein**

**Dilshad Ishmail**

**Sophia Ishmail**

**Zulaikha Maimoniot**

**Habiba Qadiri**

**Hawa Rawat**

**Zainaeb Runat**

**Aisha**

**Rukshana**

*Group Leader & Artist*

**Ian Clarke**

**Sarah Joy**

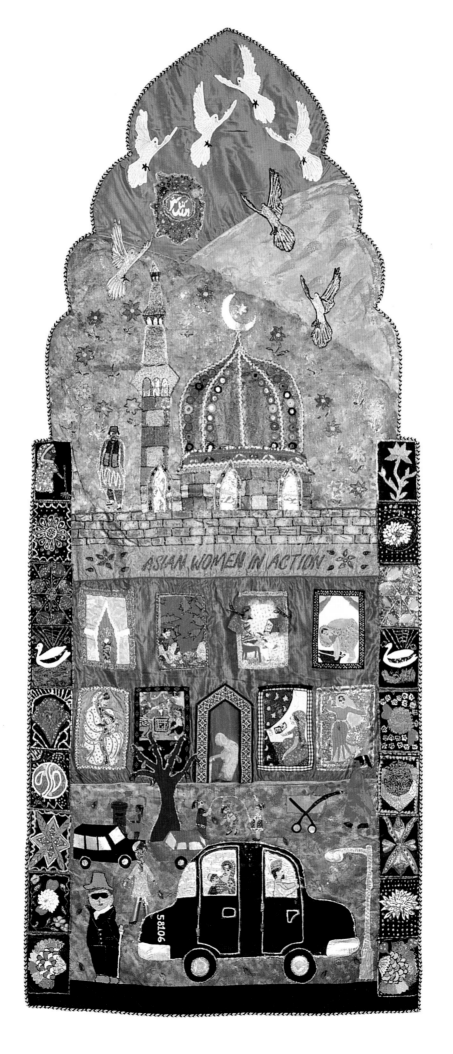

❖  ❖  ❖

# Life Story · 1994

Diverse Stitch, Nelson
Co-ordinated by Mid Pennine Arts,
Burnley, Lancashire

'Our group is made up of women from various cultures. It became clear that our central theme was how women's lives follow a similar pattern no matter what their cultural background. This is shown in the panel with the life journey beginning at birth, represented by the pregnant woman and next to her a woman holding a baby. The South Asian members of the group told us of the tradition of giving goats to a family when a child is born. The two goats in this section were made by a member of the group who owns her own goats. She spun some real goat's hair and then stitched her design. The linking borders have mostly been made by the children involved in the group. The yellow border symbolizes education and links the different cultures with ABC, 123, in English, Chinese and Urdu. The third section represents relationships and marriage with a traditional British white wedding cake against the background of a traditional Asian wedding.

'The life story then moves on to the theme of death, linking marriage with funerals by a border of places of worship in Nelson, Lancashire.... [The hanging shows other symbols –] the red rose is the symbol of Lancashire and the lotus flower is the symbol of eternal generation for existence as an unceasing cycle of birth and death.'

GROUP STATEMENT

*Participants*

**Shamim Akhtar**

**Helen Ali**

**Lyn Caldwell**

**Ruth Haworth**

**Julie Hogan**

**Jeni Keiller**

**Yinghua Lin**

**Pat Moore**

**Sarah Neville**

**Tasleem Taj**

*Group Leaders & Artist*

**Jacky Riddell**

**Caroline Slifkin**

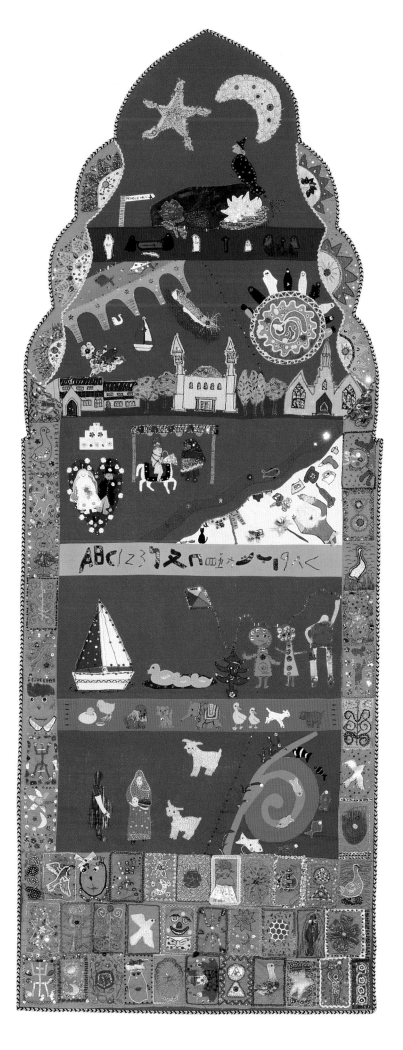

❖  ❖  ❖

# Moghul Architecture 1994

Long Island Women's Group
New York, USA
Co-ordinated by Ethnic Minority Centre
Mitcham, Surrey

'Inspiration for this panel came from miniature paintings of the Moghul period. The Moghuls were very fond of colour and geometrical designs and we wanted to reflect this in our panel.'

GROUP LEADER

*Participants*

**Fazilat Ahmed**

**Ishrat Ahmed**

**Neaz Ahmed**

**S. Ali**

**Shibani Basu**

**Rabia Begum**

**Dr Biswas**

**Sunita Chatterjee**

**Sunaya Choudhry**

**Farzana Chowdhry**

**Lina Datt**

**Nazim Ghauri**

**Shabnam Ghosh**

**Nasreen Hassan**

**Dr Aneena Hussain**

**Yasmin Hussain**

**Amita Hussain**

**Rina Islam**

**Lakhminder Jagdeu**

**Husne Jahan Molla**

**Afroza Jamal**

**Gian Kaur**

**Tanya Khan**

**Farzana Khan**

**Tasneem Khan**

**Yasmin Khan**

**Anjum Kiduai**

**Shahnaz Latif**

**Nahrein Mirza**

**Faizal Mirza**

**Siraed Mohamad**

**Pingla Naidoo**

**Pashma Rahman**

**D. Rahman**

**Hafiza Rahman**

**Sabitri Ray**

**Dipu Roy**

**Santosh Sahdeu**

**Padmini Samarasekera**

**Shuaib Sheikh**

**Pauline D'Silva**

**Noor Sultana**

**Kiran Thakkar**

**Mel Thomas**

**Rosemary Turner**

**Dotty Wanigesekera**

**Ravini Wanigesekara**

**Naila Zafar**

**Firdosi Zaman**

*Group Leaders & Artist*

**Lilly Khan**

**Razia Killeadar**

**Tasneem Mohammadally**

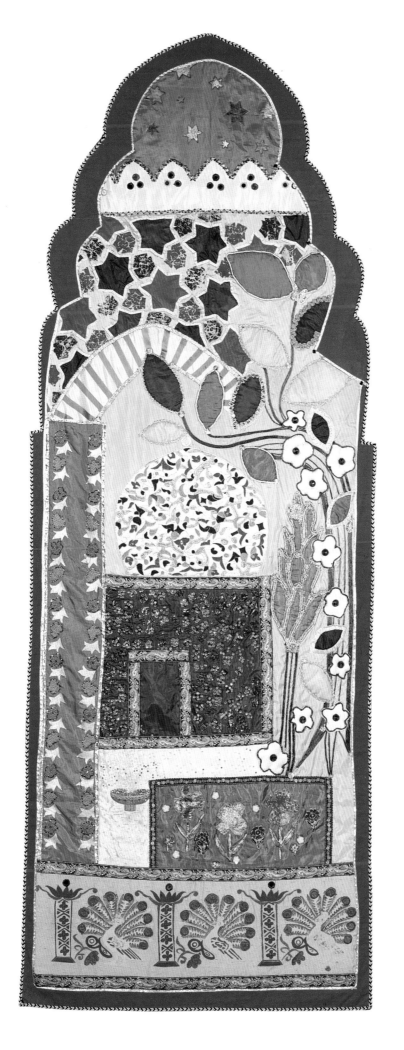

❖　❖　❖

# Coming Together · 1994

B-Tech National Course in Health and Social Care
Tower Hamlets College of Further Education
Tower Hamlets, London

'*Coming Together* was symbolic to our group as we were mixed in skills, age, culture and gender. Together we shared ideas and had lots of fun and arguments. The panel title changed several times, but the main themes throughout the work were spiritual peace and equality.'

GROUP STATEMENT

*Participants*

**Julia Bailey**

**Sandra Bernard**

**Shirin Coulan**

**Kerry Ferrugia**

**Maxine Hammond**

**Anam Haque**

**Margaret Janesien**

**Ricky Norman**

**Lorrain Norman**

**Musa Rahaman**

**Rzia Uddin**

**Linda Ulla**

*Group Leader*

**Mel Jones**

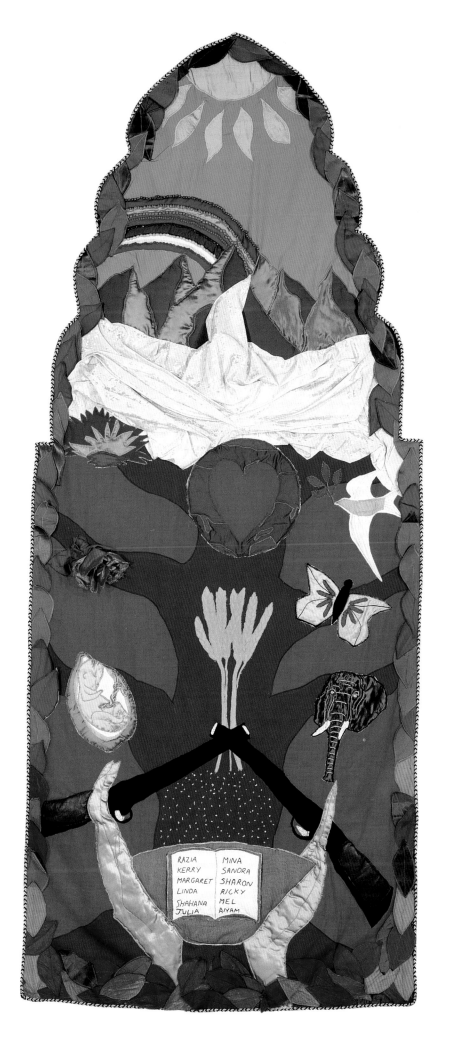

RAZIA MINA
KERRY SANORA
MARGARET SHARON
LINDA RICKY
SHAHANA MEL
JULIA ANAM

# A Celebration of Friendship
## 1994

Loughborough Design and Textile Group (ex-sandwich course
students, 1977, from Loughborough College of Art & Design)
Loughborough, Leicestershire

'It was suggested that the whole of the top hanging could be filled with an elephant's head with its trunk coming down the centre, with the background made up of the small tiles, representing some stone and marble screens seen in the Nehru Gallery. Each member of the group could then work individually on the tiles.

'Each tile is quite different with every member of the group choosing to work their small elephant in their own particular style. Many techniques have been used, and richness was achieved by using metal threads, beads and sequins, by padding and the use of tassels.

'Headdress – I chose to layer fabrics for this and cut through to reveal gold and black, stitching round the shapes on the machine with metal threads. The *shisha* were worked by buttonholing metal rings with gold thread and attaching them to the background over the mirrors. The large gold tassel was inspired by a tiny one I'd seen in the Nehru Gallery, with buttonedholed rings around the top. The fabric for the elephant had been chosen with great care. The correct weight was very important for working on such a large scale, so I finally chose a black pure silk chiffon, a 1930s fabric of my mother. This I sprayed with gold, and when lightly padded with black wadding it proved to be just right. Beads came from an old necklace. The tusks represented the next major challenge. Foreshortening is very difficult to achieve and so I was delighted to receive a postcard from Neal Street East in London showing an elephant with tusks cut off and decorated with gold rings.'

GROUP CO-ORDINATOR

*Participants*

**Suzanne Albery**

**Janice Brown**

**Audur Evyindsson**

**Elizabeth Fewings**

**Sheila Morrice**

**Pat Pierrepont**

**Elizabeth Shaw**

**Jan Trickett**

**Angela Welburn**

*Group Co-ordinator*

**Janice Hay**

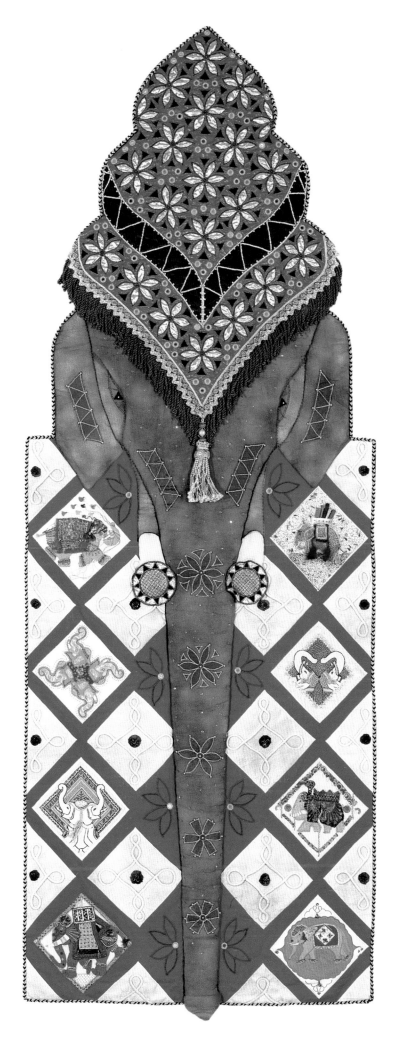

❖   ❖   ❖

# Taj Mahal · 1994

Burton Asian Women's Textile Group
Burton-upon-Trent, Staffordshire

'Most of the women in our family worked on our square. Once somebody had put it down for a bit, someone else would pick it up, and eventually it went all around the room.'

PARTICIPANT

'Nineteen women from Burton-upon-Trent met once a week to work with the artist to create their *Taj Mahal* hanging, but the comment above illustrates how the project extended beyond regular sessions and how art and creativity is part of everyday life for many people. Such skills and creativity are not necessarily recognized or valued by the wider community and projects such as the Mughal Tent Project are invaluable for us promoting community arts development.

'The Mughal Tent Project and other creative projects that have followed it in Burton, have provided both social and creative opportunities for Asian women with varying needs. Some older women found that it helped relieve some of the isolation that they felt, women with children welcomed the chance to leave their children in the crèche and do something for themselves and younger women who were not in employment enjoyed taking part in the creative process, which produced the gloriously luxuriant *Taj Mahal* hanging.'

GROUP LEADER

*Participants*

**Tasleem Ahmed**

**Shabana Akhtar**

**Shehnaz Akhtar**

**Tasleem Akhtar**

**Siauqa Akhtar**

**Fozia Bano**

**Kasloon Bano**

**Lubna Din**

**Mariam Iqbal**

**Khaula Jaffar**

**Firdous Khan**

**Sabra Khawaja**

**Azmat Mahmood**

**Shanaz Mahmood**

**Farah Naz**

**Arifa Rashid**

**June Walker**

*Group Leader & Artist*

**Michele Clerc**

**Balbir Nazran**

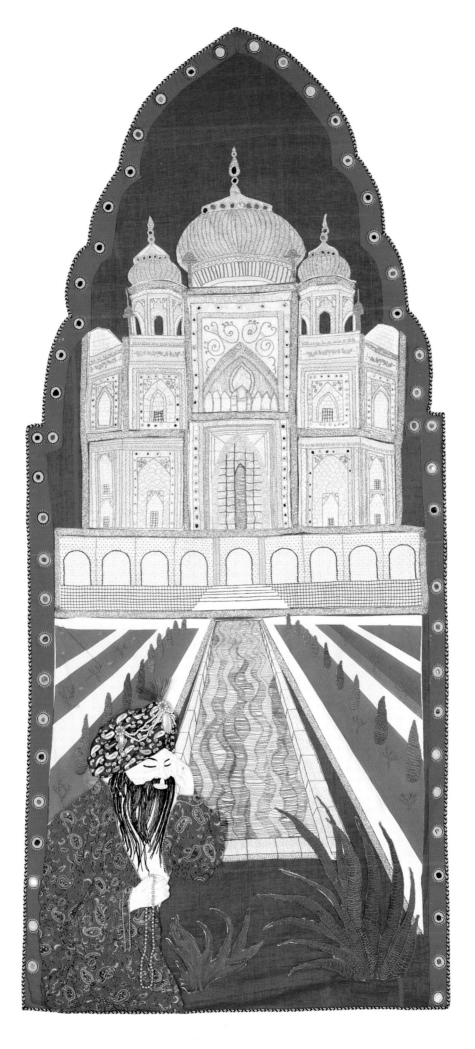

# Hope · 1995

Hopscotch Asian Women's Group
Camden, London

'The first day back after visiting the V&A everyone was keen to do something immediately. Whatever the final design, everyone agreed flowers will be included. Each person joining the project was going to produce at least one flower, and with different people joining and leaving as the weeks passed by, we ended up with lots of flowers. At the same time we also had to have an overall concept or the design would simply be a lot of unconnected *things*. Discussion centred on what aspects of people's lives we wanted to represent. It was plain that no one was interested in depicting an historical event, but "life now" interested everyone. At the same time, "life now", with its happiness, sadness, difficulties and contentment, successes, failures and hopes for the future, is coloured by a far-reaching tradition which is taken for granted and sometimes unnoticed. We wanted to represent, all the groups who use our Centre – Bangladeshi, Indian, Pakistani and Nepalese, and show from a woman's point of view the different lives we lead. The elements of women's lives, now, which we have tried to represent, are: the working woman earning a living with the computer and the sewing machine; studying in the library; and enjoying her children. London is depicted by Big Ben, the plane tree, and a pigeon; beliefs by the temple, and the crescent moon. All is approached through a beautiful archway, representing traditions and roots, surrounded and enclosed by the flowers of a garden of paradise, representing hopes and wishes for the future.'

GROUP LEADER

*Participants*

**Amina**

**Bhagobati**

**Fateha**

**Gyani**

**Guli**

**Helena**

**Kajoli**

**Khoyrun Nessa**

**Maya**

**Mina**

**Nazma**

**Rukmani**

**Saleha**

**Sharda**

**Surya**

**Zubaida**

*Group Leader & Artist*

**Tasneem Khan**

**Millie**

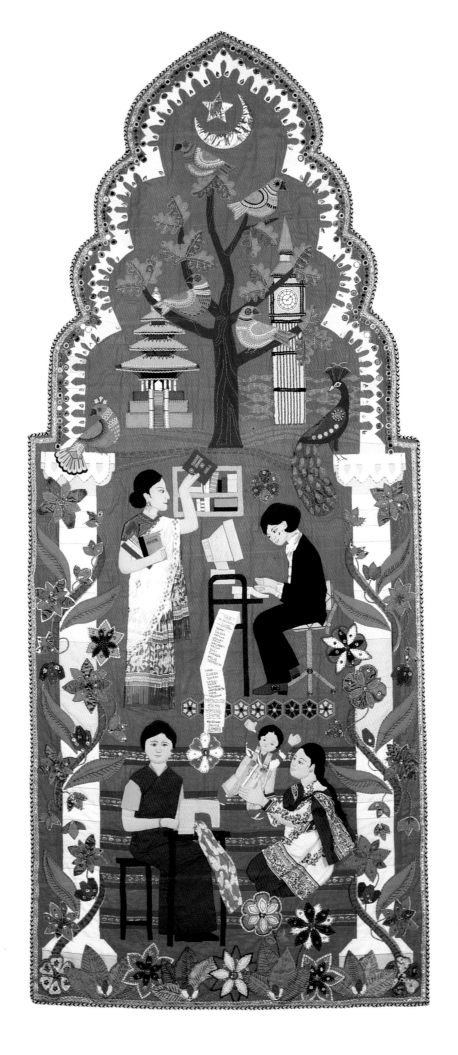

# Shah Jehan Mosque · 1995

Woking Asian Women's Association
Woking, Surrey

'Woking Asian Women's Association (WAWA) undertook the project following a visit to the Victoria and Albert Museum. The idea of an embroidery panel was formulated to express the creative and artistic talents of the members of WAWA. The group decided to depict the Shah Jehan Mosque in Woking in their panel due to the historical importance of the building, and to coincide with the centenary celebration of the Borough of Woking Council in Surrey. This is also the oldest mosque built in England and dates back to 1889.

'The embroidery was undertaken by thirty members working for almost a year over weekends and evenings. The contributors belonged to a variety of professions such as doctors, teachers, accountants and social workers. Additionally, younger members, university students and other housewives also joined in to support the project in their spare time. Each contributor brought her own expertise in drawing, sewing, embroidery, needlework and appliqué.

'A blueprint was produced by enlargement from a ninety-year-old sketch of the mosque elevation. The exact replica of the mosque in colour was created in the panel. The three-dimensional effect was produced by padding the dome and minarets, which proved difficult and required several attempts. The dome was made in green satin, finished in white and gold threads. To depict the effect of grills, fine net material was used over the green background. The entrance door to the mosque was embroidered to reveal the carvings. The front garden was laced with floral patterns and a three-dimensional entrance gate was painstakingly created which could open and close on the panel.

'WAWA arranged a function for a press view of the finished panel. This was well publicized in local papers. The panel was officially presented to the Mayor of Woking Borough in the council chambers before being submitted to the Victoria and Albert Museum. The panel has already been reserved for display at the planned Museum for Woking.'

GROUP LEADER

*Participants*

**Ishrat Ahmed**

**Tasneem Akhtar**

**Margaret Atter**

**Yvonne Baig**

**Alveena Mahoon**

**Rameeza Mahoon**

**Kausar Masood**

**Ayaila Mir**

**Aysha Mir**

**Sofia Mir**

**Yasmeen Razzaq**

**Tamannah Salam**

**Shahida Shafiq**

**Somia Shafiq**

**Madasra Zia**

*Group Leader*

**Rafeea Mahoon**

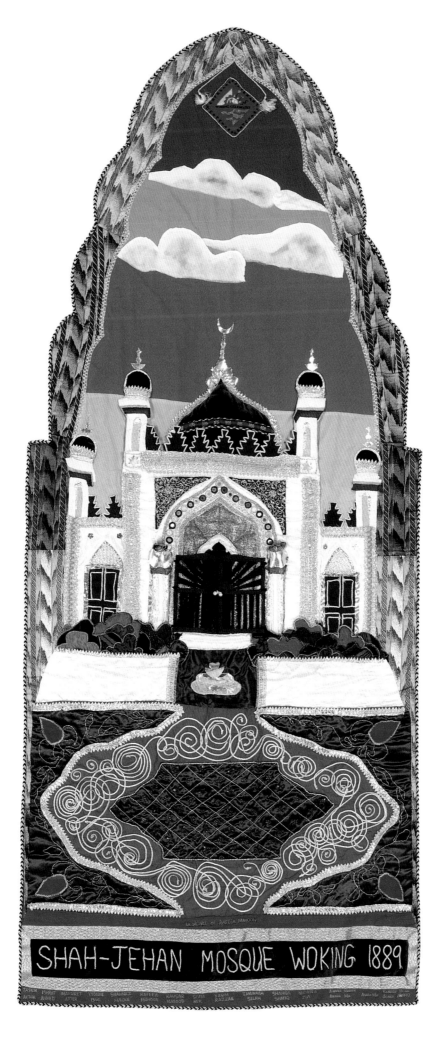

SHAH-JEHAN MOSQUE WOKING 1889

❖  ❖  ❖

# The Tree of Life · 1995

Highfield Junior School
Enfield, London

'Our project began in September 1994 with a visit to the Nehru Gallery. The children, a class of seven years old, were new to the school and their teacher and nobody quite knew what to expect. During that day, parents, children and teachers learnt together about the beautiful Indian artefacts on display in the V&A. They were able to observe and draw, sketching particular objects which fascinated them. The museum provided a unique environment, which stimulated the children's interest and imagination. For some the pattern and objects studied were new and strange but for others they were reminiscent of things at home. There was a great excitement when one little girl recognized *Tipu's Tiger* from a picture she had seen in her father's book.

'… a decision was made that "Tree of Life" would be the central theme around which children would draw their favourite object in the Nehru Gallery. Every child in the classroom made a contribution to the panel. In a previous term, the school had been fortunate enough to have had an artist-in-residence who had taught teachers and pupils the craft of *batik*. We were keen to reinforce the skills learned through this project and so decided to do our panel in batik.

'The work held the children's interest over many weeks. For them it became a very special time. As each stage unfolded and new skills were learnt, their confidence in their own ability grew. Finally they handed the finished panel to the officer from the museum who visited the school. The children will never forget their involvement with the project.'

SCHOOL CO-ORDINATOR

*Participants*

**Ozlem Acun**

**Edward Adams**

**Hakan Ali**

**Catherine Ambler**

**Zoe Andreas**

**Krystine Apostolides**

**Nayan Ashra**

**Rebecca Boakes**

**Alex Broomfield**

**Alistair Buchan**

**Sule Cagaloglu**

**Costas Demosthenous**

**Ben Goodyear**

**Ayshe Huseyin**

**Shanaz Hussain**

**Michelle Ifill**

**Sonia Jadeja**

**Alkin Koseoglu**

**Nicholas Kyriakides**

**Stefan Lue**

**Deniz Mehmet**

**Maria-Lena Myristis**

**Katie Oliver**

**Beliz Ozcurumez**

**Selina Robinson**

**Ronak Shah**

**Stelios Shakalis**

**Michael Spyrou**

**Sophie Varnava**

**Joe Vera**

**Ebru Zorba**

*School Co-ordinator*

**Val Turner**

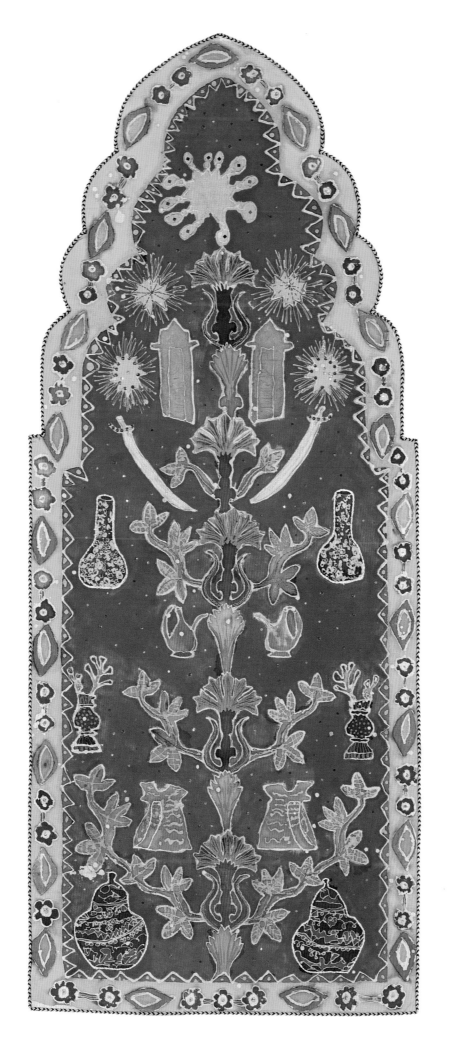

<div>❖ ❖ ❖</div>

# Aspirations · 1995

### Godolphin Infant School
### Slough, Berkshire

'We spent a lot of time looking at examples of Mughal art and mosques. The children sketched lots of ideas, including tile designs, figures and flower patterns from their visit to the V&A.

'It was decided that the panel would be based on pattern, symmetry, shape and colour. This was to incorporate themes found in Islamic art seen in the V&A. We decided to use a blue and white colour scheme echoing the tiles seen at the museum. The tiles would then form the pillars or give a wall effect supporting domes, which would gradually get smaller, to give an impression of space and distance. The children had made lots of sketches in the galleries and back at schools from other resource material. Their drawings were transferred on to the fabric by directly photocopying on to the material. Once on the fabric, the pictures were coloured with fabric pens and outlined with gold and silver *gutta*. The border was completed in the same way, and sequins and *shisha* glass gave the final touch. The children also remembered a tie-dyed piece of textile at the museum and decided to use that as a background to their final design.'

SCHOOL CO-ORDINATOR

*School Children*

**Wakas Ahmed**

**Soria Arif**

**Faisal Ashraf**

**Harpreet Basson**

**Daljit Bhatn**

**Hardeep Birk**

**Hardeep Boyal**

**Babbar Butt**

**Gurvinder Dyal**

**Yassen Fazal**

**Yasir Hussain**

**Mandeep Jabble**

**Gurmail Jugpall**

**Anisha Khan**

**Navdeep Khara**

**Kamine Kumar**

**Jaswinder Panesar**

**Sundeep Phull**

**Mehrose Raja**

**Humzah Rafiq**

**Uma Rafiq**

**Usman Rashid**

**Neesha Rattu**

**Rushdah Saghir**

**Harkamaljit Sall**

**Saitunterjit Sandhu**

**Amreet Sangha**

**Aqeel Shah**

**Navdeep Thiara**

**Sukdeep Thiara**

*School Co-ordinator & Artist*

**Angela Gibson**

**Sarbjit Natt**

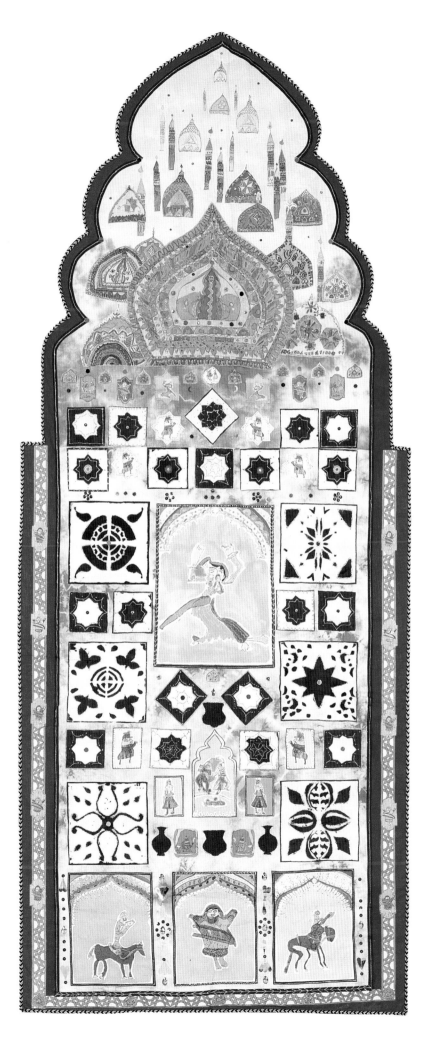

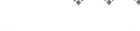

# Patchwork · 1995

Ansford Community School &
Members of Castle Cary and Ansford Community
Somerset

'As this was our second panel we decided to go for something abstract, based on patterns we had seen in the lattice screens (*jalis*) in the Nehru Gallery. At our first session we coloured in some photocopies of Islamic patterns which we then used to make small collage mock-ups of our proposed panel. Someone also brought along some pictures of the Alhambra, which she had recently visited. We incorporated some of the tile patterns she had seen there into our design.

'We decided to use traditional English patchwork technique to create our panel as we felt it was nice way of fusing ideas from many cultures. Everyone chose a section to work on and got stitching. Soon we had several pieces ready to stitch on to our mihrab-shaped red background. Much discussion ensued as to what finishing touches we should use. We went for quite a lot of gold, sequins and mirror glass (*shisha*), as we felt it would give our English patchwork a more Asian look. We were quite pleased with the result and enjoyed the way in which our glitzy bits shimmered when the light caught.'

GROUP LEADER

*Participants*

**Ann Bertalot**

**Gabrielle Davies**

**Nora Field**

**Shirley Knapman**

**Jane Long**

**Freda Sharp**

**Ruth Stones**

**Joyce Trikilis**

**Sallie Vallins**

**Joan Williamson**

*Group Leader & Teachers*

**Lydie Gardner**

**Lin Hawkins**

**Laura Tillings**

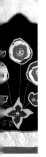

❖ ❖ ❖

# Islam Now · 1995

Falkirk Asian Women's Group
Falkirk, Scotland

'It had been decided that each participant in the project should submit an individual rough sketch of the design. Although some felt tentative, others produced interesting individual ideas incorporating a variety of design elements, many of which were in the final piece of work ... Already at this stage the notion was being discussed of dividing the panel into separate design areas which could be unified by the mihrab shape.

'Nadira wanted to make a poignant statement about what it can be like to be an Asian woman living outside the mother country where the pressures of being a wife and mother can at times almost seem imprisoning, and there can be a sense of loneliness because of being apart from other family members who are still in the home country – a sensation she feels especial at the times of traditional festivals. She has depicted this by stitching a gilded cage surrounding an eye which sheds a tear. Several members of the group decided to make a statement about how important Islam is to them and produced images representative of their religion such as the Holy Koran, a mosque, a minaret and the Five Pillars of Islam. Tasneem chose to depict the flame of her faith alongside symbols of Scotland such as a church and a castle. Another reference to traditional customs was made in the form of hands brightly decorated with henna, while Yasmeen used coloured hands of different races to represent the caring friendship when the people of two nations live harmoniously together.

'The women felt that their sewing has advanced further as a result of this experience and that they had no idea that design skills lay latent in them until now. The fact that the work has been so completely shared has been very satisfying and the women have noted some of the new talents that have emerged in some of the quieter members of the group, who have not before had an opportunity like this.'

GROUP LEADER

*Participants*

**Shenaz Ahmed**

**Nusrat Khaliq**

**Noreen Khan**

**Kauser Khan**

**Tahira Mahmood**

**Tasneem Rashid**

**Yasmeen Rashid**

**Nazia Saddiq**

**Shagufta Saleem**

*Group Leaders & Artists*

**Suzi Cuthbertson**

**Elizabeth Guest**

**Nasreen Malik**

**Sarbjit Natt**

**Kim Paterson**

**Nadira Sadiq**

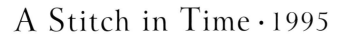

# A Stitch in Time · 1995

Ma Tu's Group

Tan-pa-waddy, Mandalay, Burma

'They all enjoyed greatly working on this project. I think it was a pleasure for them to come to Ma Tu's house – she always welcomed them with some form of refreshments.'

*Participants*

**Khin Pa Pa Hlaing**

**Maw Maw**

**Nyo Nyo San**

**Ma Shan**

**Mar Mar Thu**

**Khin Mar Way**

*Group Co-ordinator*

**Ma Tu**

THE PANELS

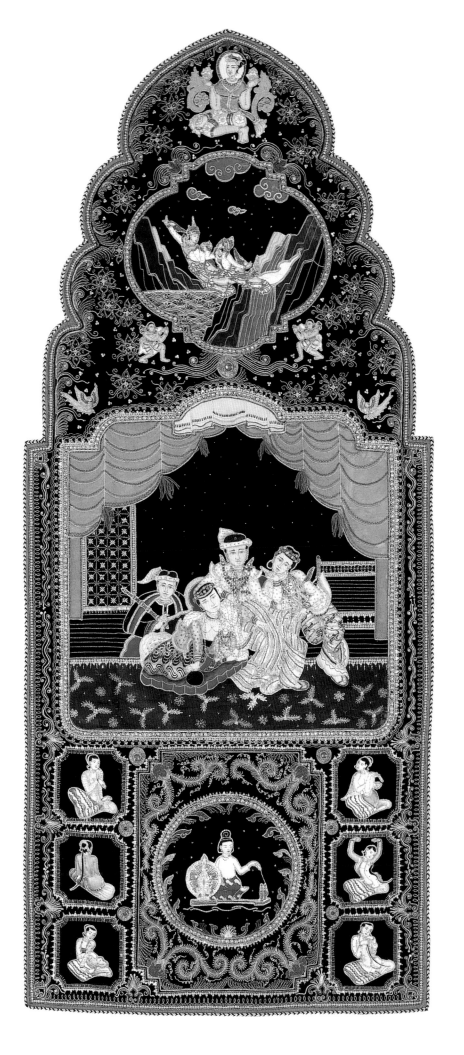

# An Open Door · 1995

Women's Society of the UAE
Dubai, United Arab Emirates

'We worked as a group of nine ladies from seven different nationalities. It is truly a great effort, an example of a multinational one. We are celebrating our country and all its people who bring such diversity to our society. Our panel is depicting Dubai, past and present, where old-world values live alongside a modern and progressive society – the familiar landmarks of Dubai like the Creek Club, wind towers, palm trees, pearls, mosques, a man wearing a *khandura* and a woman in a *hijab*. Each and every part of the collage is handmade, which includes braid weaving for the edges, embroidered strips for buildings, as well as the *talli* – a traditional method of embroidery for clothes and tapestry, perfected by national women. We hope our panel will also inspire our children and show them the value of their heritage.'

GROUP LEADER

*Participants*

**Shaheen Hamza**

**Prue Mason**

**Sultana Rabi**

**Jean Sawyer**

**Natalie Sadler**

**Ruth Sadler**

**Durriyeh Vasi**

*Group Leader & Artist*

**Tina Ahmed**

**Mariam Benham**

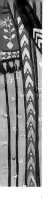

❖   ❖   ❖

# Shah Jehan · 1995

Ethnic Minority Centre
Mitcham, Surrey

'The Taj Mahal is one of the most famous buildings in the world and was built in the reign of Shah Jehan. We are celebrating our cultural heritage through the legacy of Shah Jehan.'

GROUP LEADER

*Participants*

**Fazilat Ahmed**

**Ishrat Ahmed**

**Neaz Ahmed**

**S. Ali**

**Shibani Basu**

**Rabia Begum**

**Dr Biswas**

**Sunita Chatterjee**

**Sunaya Choudhry**

**Farzana Chowdhry**

**Lina Datt**

**Nazim Ghauri**

**Shabnam Ghosh**

**Nasreen Hassan**

**Dr Aneena Hussain**

**Yasmin Hussain**

**Amita Hussain**

**Rina Islam**

**Lakhminder Jagdeu**

**Husne Jahan Molla**

**Afroza Jamal**

**Gian Kaur**

**Tanya Khan**

**Farzana Khan**

**Tasneem Khan**

**Yasmin Khan**

**Anjum Kiduai**

**Shahnaz Latif**

**Nahrein Mirza**

**Faizal Mirza**

**Siraed Mohamad**

**Pingla Naidoo**

**Pashma Rahman**

**D. Rahman**

**Hafiza Rahman**

**Sabitri Ray**

**Dipu Roy**

**Santosh Sahdeu**

**Padmini Samarasekera**

**Shuaib Sheikh**

**Pauline D'Silva**

**Noor Sultana**

**Kiran Thakkar**

**Mel Thomas**

**Rosemary Turner**

**Dotty Wanigesekera**

**Ravini Wanigesekara**

**Naila Zafar**

**Firdosi Zaman**

*Group Leaders & Artist*

**Lilly Khan**

**Razia Killeadar**

**Tasneem Mohammadally**

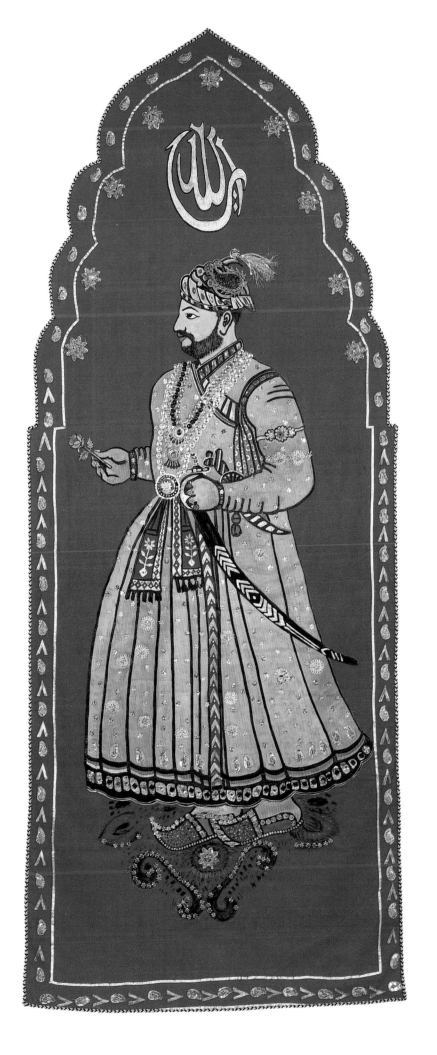

❖ ❖ ❖

# Bird
## 1995

Windsor Girls' School
Windsor, Berkshire

# Migration
## 1995

Windsor Girls' School
Windsor, Berkshire

The benefits have been many and varied, some large and long-term, some small but important to individuals and the group as a whole. To have the opportunity to lead a group project in practical work is quite a rare situation in secondary school, as we are driven by exams with their "each pupil for themselves" approach. Most importantly, cross-curricular education does not happen when the outcome of exam-results league tables enters the forum.

'It was also good for the girls to have contact with live artists – to see professional portfolios and understand how commission work needs supplementing with bread-and-butter work to survive was a wonderful experience for the whole group. Our artist demonstrated skills and had an amusing anecdotal way of passing on snippets of cultural and historical gems … which brought alive the various aspects of Indian textiles from a human angle.'

SCHOOL CO-ORDINATOR

*Participants*

**Sophie Armstrong**

**Sonya Ball**

**Carlie Batterham**

**Tracy Belcher**

**Anna Bracher**

**Debra Bracher**

**Gemma Cozans**

**Louise Curnuck**

**Nicola Daly**

**Samantha Davey**

**Laura Davis**

**Adele Dupen**

**Amanda Gibson**

**Victoria Haire**

**Juliet Haylor**

**Samantha Haywood**

**Kathryn Hedges**

**Melissa Jesicek**

**Furheen Khan**

**Victoria Lewis**

**Kay Martin**

**Hannah Miles**

**Anne Paramore**

**Jayne Partington**

**Samantha Randall**

**Nichola Roberts**

**Joanna Roache**

**Nicola Salmons**

**Katie Samways**

**Emma Skinners**

**Helen Smith**

**Jasmine Sohanpol**

**Paaru Tanna**

**Alexandrea Watts**

**Karen Wimpory**
**Clare Young**

*School Co-ordinator & Artists*

**Anita Chowdrey**

**June James**

**Joan McQuillan**

**Bird** *1995*

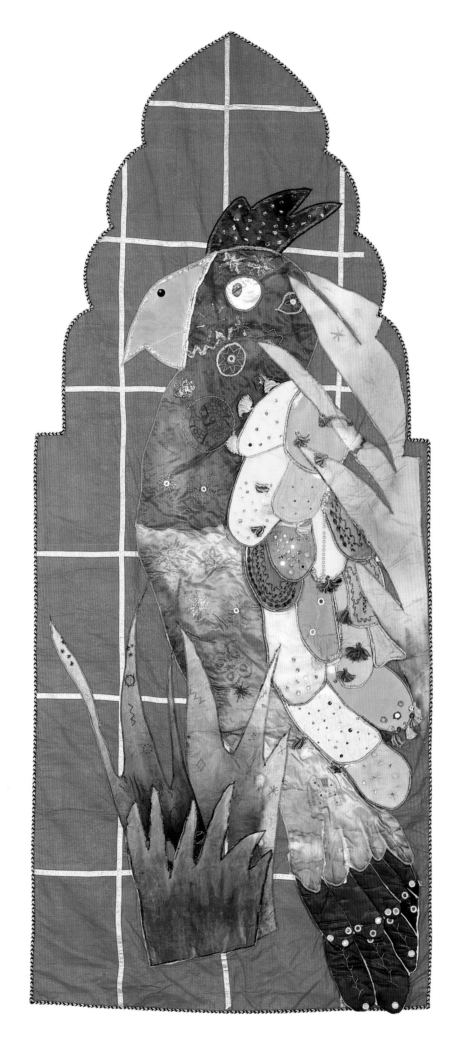

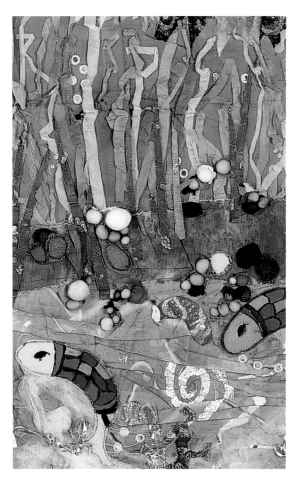

*'Our artist demonstrated skills and had an amusing anecdotal
way of passing on snippets of cultural and historical gems…
which brought alive the various aspects of Indian textiles from a
human angle.'*

**Migration** *1995*

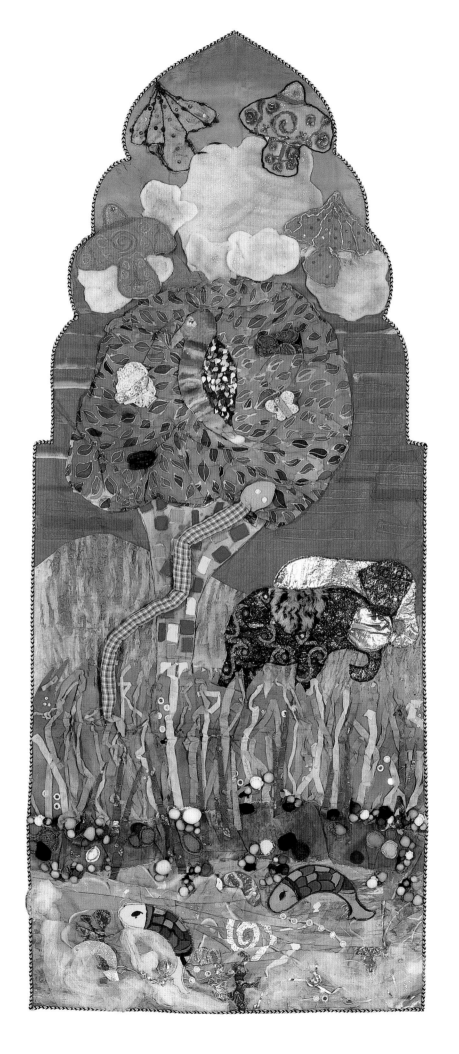

❖ ❖ ❖

# Flowers and Birds · 1995

Montem Infant School
Slough, Berkshire

'It is hoped this project will promote interest in the museum and encourage co-operation amongst the children from all backgrounds.'

TEACHER

*Participants*

**Nazreen Afzal**

**Nawaz Ahmed**

**Saboor Ali**

**Irfan Anwar**

**Baldeep Assi**

**Humaira Baig**

**Debra Barnes**

**Zaigham Chaudhry**

**Jaspreet Guhataour**

**Harpreet Hansra**

**Yasir Hussain**

**Sobia Iqbal**

**Kerry Jones**

**Rupinder Kataria**

**James Kemp**

**Muhammed Awais Khan**

**Sameer Khan**

**Kamaljit Khun Khun**

**Nazish Khurshid**

**Hermeet Matharu**

**Saira Mirza**

**Dawinder Multani**

**Davinder Randhawa**

**Aumman Raza**

**Mohammed Raza Saba**

**Shane Sharp**

**Nitin Tugnet**

**Dorian Vanterpool**

**Harpeel Vilkhu**

*Group Leaders & Artist*

**Stephanie Bugden**

**Alison Little**

**Sharon Lutchman**

**Cheryl Pepper**

*Parent Helpers*

**Mrs Chaudhry**

**Mrs Hansra**

**Mrs Sien**

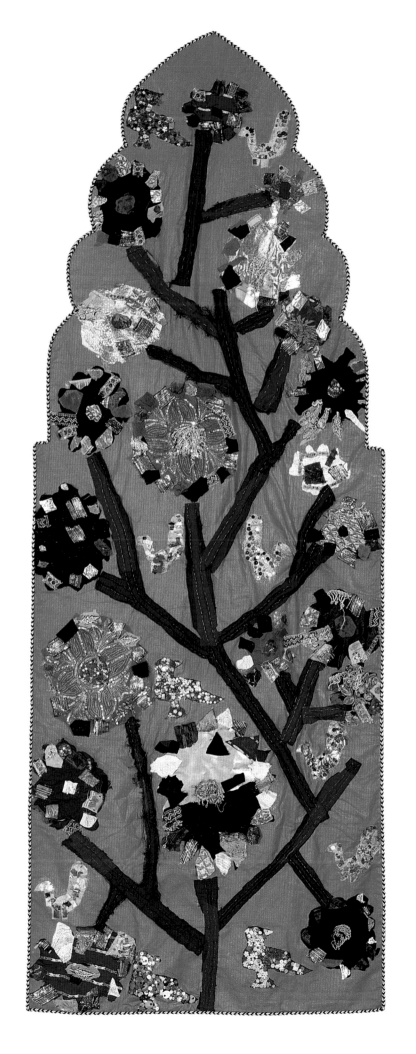

# Beauty and Elegance · 1995

Tipton Muslim Women's Group
Tipton, West Midlands

# Bride 1995

Tipton Muslim Women's Group
Tipton, West Midlands

'Being part of a nationwide project was an important incentive for the group to make their contribution. The project brought together two generations of women – young and older girls working with older women with ages ranging from thirteen years to forty-five years. The project enabled women, who do not normally come out of their home, to socialize and share their skills and experiences with the younger generation. The participants were from Pakistani and Bangladeshi backgrounds – two different cultures meeting together. The ideas for the panels came from the group's visit to the Nehru Gallery at the Victoria and Albert Museum.'

GROUP LEADER

'In our community many girls are getting married. We wanted to show this in our panel. We wanted our bride to be different to a normal bride, we decided to dress her in sky blue rather than traditional red. We have learnt to work together to produce a large piece of work in a set time and learnt the skills of appliqué and *kantha* stitch.'

PARTICIPANT

*Participants*

**Kolsoma Begum**

**Meorum Begum**

**Razia Begum**

**Rohima Begum**

**Shajeda Begum**

**Shafia Begum**

**Minara Begum**

**Razia Begum**

**Shanara Begum**

**Robina Bi**

**Fathema Bibi**

**Jamila Kausar**

**Syeda Khatun**

**Hazara Nessa**

**Khadiga Nessa**

**Nasreen Nessa**

**Hawarun Nessa**

**Sayarun Nessa**

**Khalida Rasool**

**Razia Sattar**

**Fatima Wadud**

*Group Leader & Artist*

**Jessica Harris**

**Ranbir Kaur**

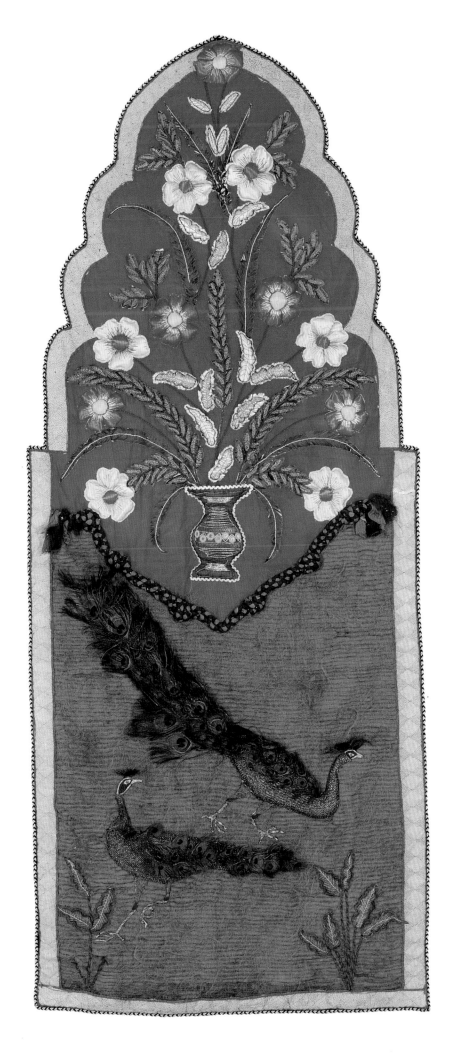

'In our community many girls are getting married. We wanted to show this in our panel. We wanted our bride to be different to a normal bride, we decided to dress her in sky blue rather than traditional red.'

**Bride** 1995

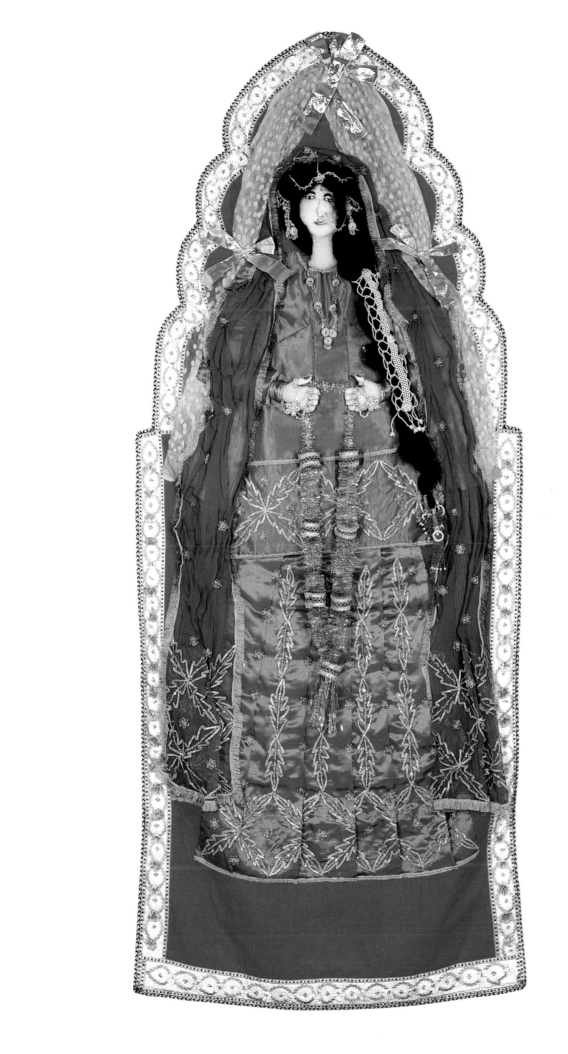

❖ ❖ ❖

# Nokshi Katha · 1995

Ethnic Minority Centre
Mitcham, Surrey

'We have used the most popular form of needlework in Bangladesh, *nokshi katha*, to create the patterns and designs in our work. This panel reflects our lives in Bangladesh villages with objects that remind us of our homes and childhoods.'

GROUP LEADER

*Participants*

**Fazilat Ahmed**

**Ishrat Ahmed**

**Neaz Ahmed**

**S. Ali**

**Shibani Basu**

**Rabia Begum**

**Dr Biswas**

**Sunita Chatterjee**

**Sunaya Choudhry**

**Farzana Chowdhry**

**Lina Datt**

**Nazim Ghauri**

**Shabnam Ghosh**

**Nasreen Hassan**

**Dr Aneena Hussain**

**Yasmin Hussain**

**Amita Hussain**

**Rina Islam**

**Lakhminder Jagdeu**

**Husne Jahan Molla**

**Afroza Jamal**

**Gian Kaur**

**Tanya Khan**

**Farzana Khan**

**Tasneem Khan**

**Yasmin Khan**

**Anjum Kiduai**

**Shahnaz Latif**

**Nahrein Mirza**

**Faizal Mirza**

**Siraed Mohamad**

**Pingla Naidoo**

**Pashma Rahman**

**D. Rahman**

**Hafiza Rahman**

**Sabitri Ray**

**Dipu Roy**

**Santosh Sahdeu**

**Padmini Samarasekera**

**Shuaib Sheikh**

**Pauline D'Silva**

**Noor Sultana**

**Kiran Thakkar**

**Mel Thomas**

**Rosemary Turner**

**Dotty Wanigesekera**

**Ravini Wanigesekara**

**Naila Zafar**

**Firdosi Zaman**

*Group Leaders & Artist*

**Lilly Khan**

**Razia Killeadar**

**Tasneem Mohammadally**

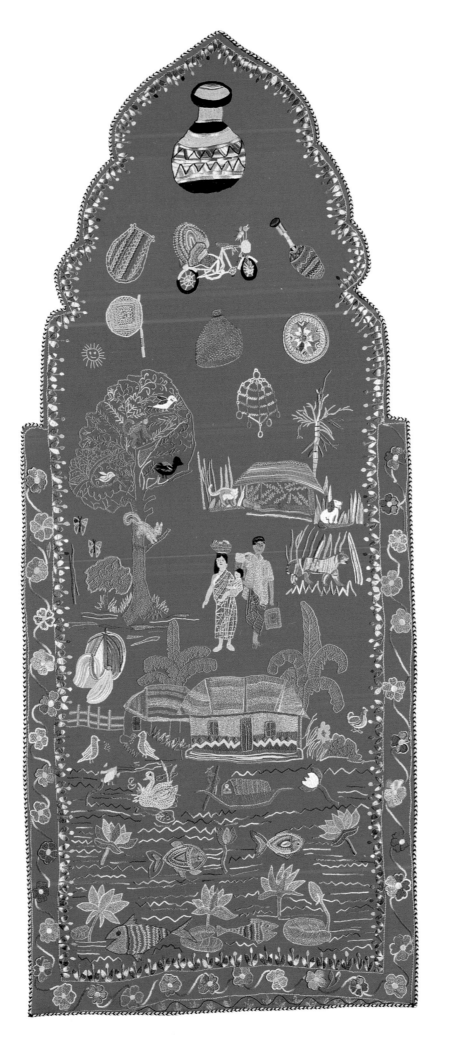

# Five Pillars of Islam · 1995

Bangladesh Welfare Association

Croydon, Surrey

'Our panel may not address the racial problem that exists in the world today, but it is hoped that it will enlighten people's views and promote greater harmony and understanding of different cultures.'

GROUP STATEMENT

*Participants*

**Sufia Ali**

**Parveen Awal**

**Jahanara Begum**

**Sabia Begum**

**Salma Begum**

**Saleha Khatun**

**Badrun Mia**

**Fauzia Zaman**

**Nadira Zaman**

**Mr Zaman**

*Group Leaders*

**Farida Ahsan**

**Rajia Rahman**

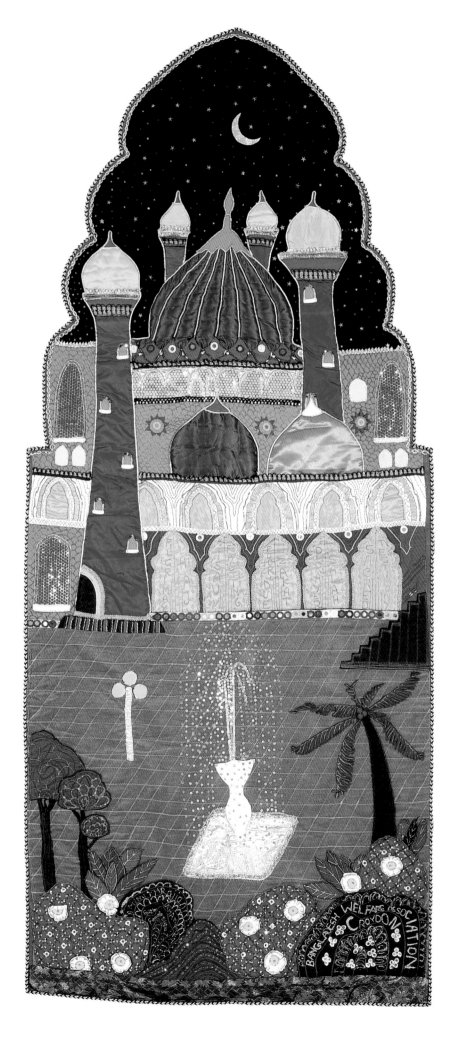

# The Banascrafts Panel · 1996

Sewa Banaskantha & Dastkar

Banaskantha, Gujarat, India

'We decided that two women leaders from each craft community would work on the piece together, and that all six women come together at the Banascrafts Centre in Radhanpur so that it would be a truly co-operative project (with all the inevitable gossip, discussion, debate, competition and interaction thrown in!) instead of being done in bits and pieces by each community in turn in their own villages.

'The women all agreed that since the panel was going abroad it should be more traditional looking and representative of Banaskantha than if the piece was being made for being shown in India…. We decided to work within the usual format of a *dharanyia* hanging, with most of the motifs stiff and stylized and left and right sides matching mirror images of each other. The only unmatching anachronistic, anarchic elements would be the figures of the women, whom we decided would be full of life and activity – filling up the blank spaces in between the formal elements of sun and stars, elephants, palms, camels and flowering plants. These would represent the warmth, strength and fullness, the fertility and flowering of the women's lives, now that they worked together, using their craft as means of income generation and social and economic growth.

'Once the basic design was marked out in the collage of different festive motifs of animals and flowers arranged in formal, symmetric groupings around a large, central burst, we selected a mix of fabric for the patchwork sections and co-ordinated embroidery thread colours to match. Fabric used was block-printed, vegetable dye fabric from Deesa, cotton satin, resist dyed *mashru* from Kutch and some plain shades of matching and contrasting *gajiya* coarse handloom and poplin. All the fabric was indigenous, locally available, and part of the local costume traditions, though both the mashru and Deesa prints had died out till revived by Sewa for the use as raw material for its product development.'

GROUP LEADER

*Participants*

**Puri-ben V. Ayar**

**Savi-ben Debhabhai Ayar**

**Bhikabhai**

**Divali-ben**

**Mahadevbhai**

**Vimla-ben Parmar**

**Jomi-ben Raigoor**

**Jayrambhai Raigoor**

**Subhadra-ben**

*Group Leader*

**Laila Tyabji**

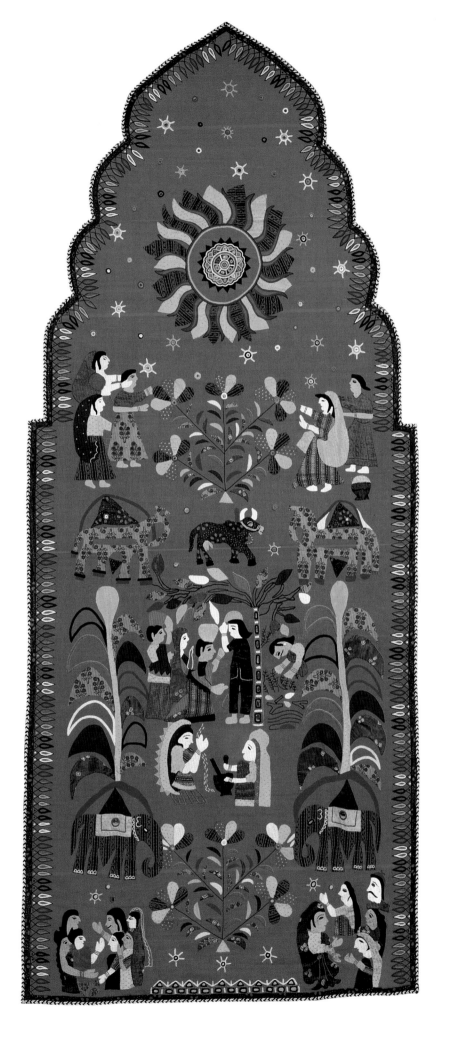

❖ ❖ ❖

# Akbar · 1996

Los Angeles Women's Group, USA

Co-ordinated by Ethnic Minority Centre
Mitcham, Surrey

'There is so much inequality in the world today. In our history Emperor Akbar represents justice which we would all like to aspire to.'

GROUP LEADER

*Participants*

**Fazilat Ahmed**

**Ishrat Ahmed**

**Neaz Ahmed**

**S. Ali**

**Shibani Basu**

**Rabia Begum**

**Dr Biswas**

**Sunita Chatterjee**

**Sunaya Choudhry**

**Farzana Chowdhry**

**Lina Datt**

**Nazim Ghauri**

**Shabnam Ghosh**

**Nasreen Hassan**

**Dr Aneena Hussain**

**Yasmin Hussain**

**Amita Hussain**

**Rina Islam**

**Lakhminder Jagdeu**

**Husne Jahan-Molla**

**Afroza Jamal**

**Gian Kaur**

**Tanya Khan**

**Farzana Khan**

**Tasneem Khan**

**Yasmin Khan**

**Anjum Kiduai**

**Shahnaz Latif**

**Nahrein Mirza**

**Faizal Mirza**

**Siraed Mohamad**

**Pingla Naidoo**

**Pashma Rahman**

**D. Rahman**

**Hafiza Rahman**

**Sabitri Ray**

**Dipu Roy**

**Santosh Sahdeu**

**Padmini Samarasekera**

**Shuaib Sheikh**

**Pauline D'Silva**

**Noor Sultana**

**Kiran Thakkar**

**Mel Thomas**

**Rosemary Turner**

**Dotty Wanigesekera**

**Ravini Wanigesekara**

**Naila Zafar**

**Firdosi Zaman**

*Group Leaders & Artist*

**Lilly Khan**

**Razia Killeadar**

**Tasneem Mohammadally**

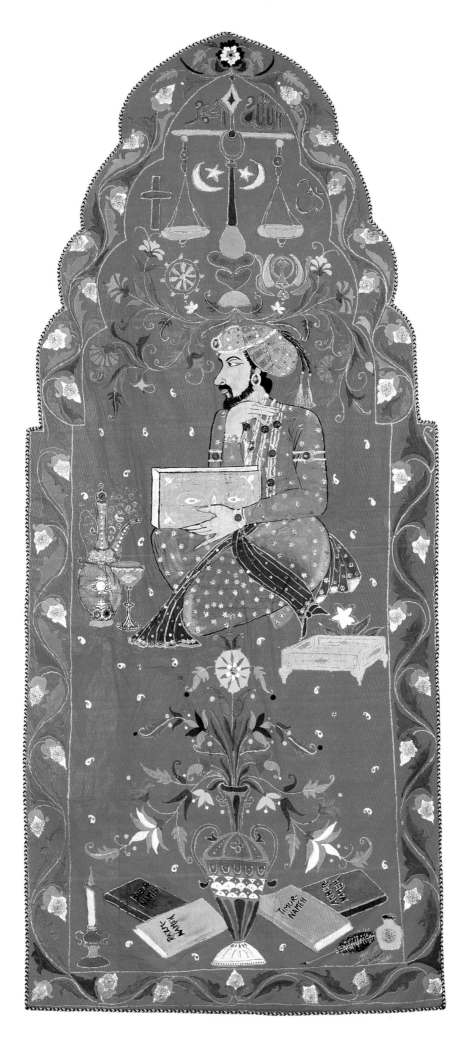

❖  ❖  ❖

# Glimpses of Pakistan · 1996

Karigari Group
Karachi, Pakistan

*Participants*

**Nighat Daudi**

**Amina Ghazi**

**Talat Hashimi**

**Lily Mahmood**

**Fauzia Memon**

**Shahnaz Mirza Iqbal**

**Seema Saddiki**

**Yasmin Saleh**

**Zeenat Shah**

**Reena Zafar**

**Ayesha Zahid**

*Group Co-ordinator*

**Talat Hashimi**

'We have benefited from the social get-together as well as the team work. Our panel has made use of motifs which are nationally recognized and many were also used during the Mughal period. [Some of] these motifs are:

- The *Charkha* (spinning-wheel) – used till recent times for weaving thread and cloth. Nowadays used in cottage industry for weaving the popular *khadar* cloth.

- The *Chat-a-pati* (patchwork) – a design made by sticking different coloured pieces of material together and then embroidering with gold threads and beads. The design was especially popular in the Mughal era.

- *Juzdan* – a cloth case-covering used for religious books.

- *Gota Work* – very popular work done with gold and silver threads on ceremonial clothes. In the Mughal era this was done in real gold and silver threads.

- The *Bewta* – a traditional handbag made out of decorative material and used by the Begums of the Mughal era to carry betel nuts, betel leaf and cardamom, still being used today when wearing traditional dresses.

- *Kameez* – a shirt with a big front-pocket, worn by the Baluchi woman, beautifully embellished with bells and beads.

- *Ghoogu Ghora* – a colourful horse of paper mâché. A toy popularly played with by young children in the villages.

- The *Dhol* – a musical instrument played on festive occasions.

- *Crochet* – a technique very popular in the West and the East both with the younger and older generations. Used in Indo–Pakistan by women to decorate their *kurtas* and *duppattas*.

- *Sindhi Mirrorwork* – incorporating pieces of mirror into an ethnic design.'

GROUP CO-ORDINATOR

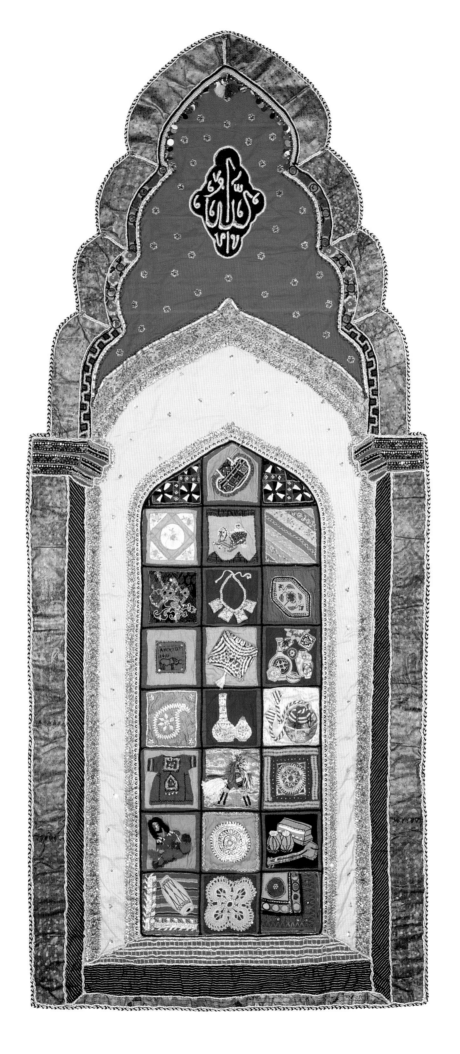

❖   ❖   ❖

# Weaning · 1996

Steel's Lane Health Centre
Tower Hamlets, London

'This panel is the result of a partnership between Stepney Nursing Development Unit [NDU] and 'A' Team Arts Education in Tower Hamlets. The NDU wanted to attract local Bangladeshi women to the Steel's Lane Health Centre in order to promote breast-feeding and good weaning practices. Images representing pregnancy, breast-feeding and weaning were chosen from Health Service leaflets. Recipes for healthy eating in each case were included with drawings of the ingredients. A sour green curry with no chillies for pregnancy when a woman craves sour flavours; a fish curry for breast-feeding; rice and lentils, yoghurt, fish and chapattis for weaning babies. There are also rice cakes that are made to celebrate the baby's first birthday.'

GROUP LEADER

*Participants*

**Tahsina Ahmed**

**Monwara Akhtar**

**Ferdoufi Begum**

**Misba Begum**

**Janeda Begum**

**Bilkis Begum**

**Aysha Begum**

**Parveen Begum**

**Rabia Begum**

**Fatema Begum**

**Moriam Begum**

**Joybun Bibi**

**Rufzan Bibi**

**Shally Chowdhury**

**Saleha Khanom**

**Kaleda Khanum**

**Rehima Khanum**

**Rekha Khanum**

**Jaheda Khatun**

**Shahida Nazir**

**Zebun Nessa**

*Group Leaders & Artists*

**Mariam Bibi**

**Geraldine Bone**

**Val Buxton**

**Rahela Choudhury**

**Julia James**

**Sarbjit Natt**

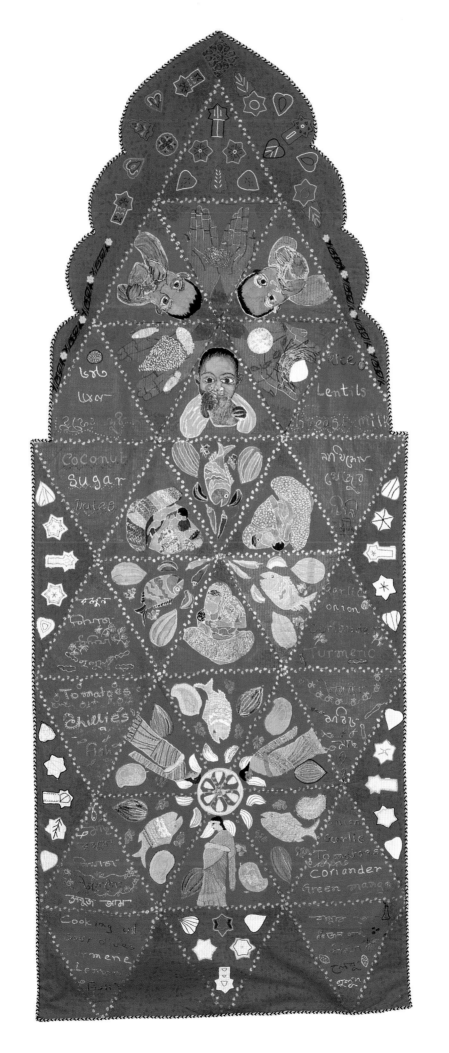

# Market · 1996

THE PANELS

'At the Nehru Gallery the women saw miniature paintings of ordinary tradespeople selling their goods. The group wanted to make a link with the way stallholders display and sell their wares in our local market – Whitechapel.

'The women visited the market with cameras and working in pairs took pictures of goods on display. When the prints were shown to the groups, each pair described the pictures and what they felt about it. Whilst we were in the market, the London Hospital helicopter ambulance flew overhead and all the women took photographs of it. They felt this was an unusual sight and wanted to feature it in the hanging.

'The workshops were devised as short courses in textile techniques so all the women experimented with batik, printing and machine embroidery before commencing on the hanging.'

GROUP STATEMENT

*Participants*

**Afia**

**Johura**

**Rubea**

**Runa**

**Rushida**

**Shahida**

**Shuhala**

**Tulip**

*Group Leaders*

**Geraldine Bone**

**Maria Chambers**

**Georgie Wemyss**

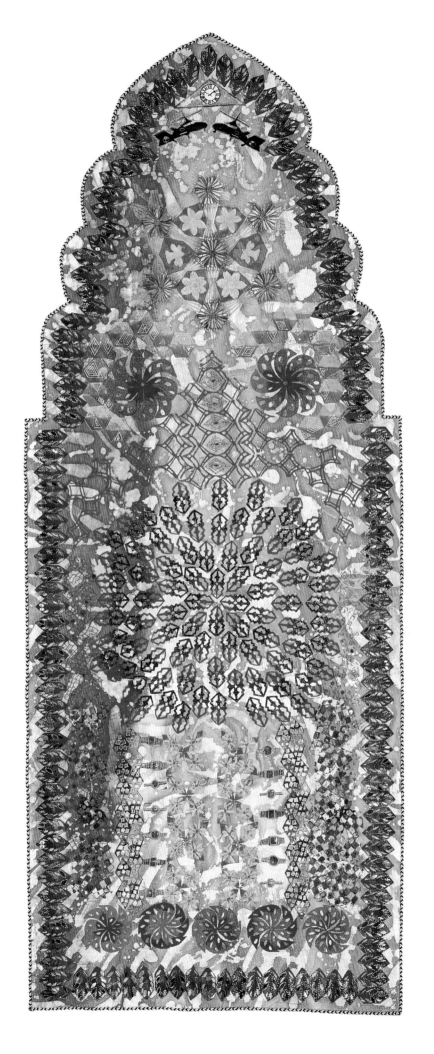

# Aston Hall Inspiration · 1996

Aston Hall Asian Women's Textile Group
Co-ordinated by Birmingham Museum and Art Gallery
Aston, Birmingham

'I became very involved with the group and found out you can get further in life without a degree. There are ladies in the group of all races and different communities. We all work together as a team and enjoy everybody's company. This also enables us to talk about our different backgrounds and religions.'

PARTICIPANT

'This has made a tremendous change in us, using our ability and trying our best to revive lost traditions which have been forgotten, and show the youngsters of today what abilities and capabilities we had.'

PARTICIPANT

'When my children began school I gradually began to embroider again and in 1992 I joined the Aston Hall Women's Group. As a group we have been to schools, universities, community centres, hospitals, health centres and libraries to demonstrate embroidery. I realized as I attended Aston Hall that my work was being valued as an art, which wouldn't have been appreciated at home. Going to meetings and conferences was something I would never have experienced on my own.'

PARTICIPANT

*Participants*

**Nahid Begum**

**Salujana Bhatt**

**Satpal Kaur Bhogal**

**Shabnum Butt**

**Rama Chandegra**

**Rehla Choudry**

**Yasmin Furdous**

**Masooda Kazi**

**Kushid Khan**

**Naseem Khan**

**Fatima Mukadam**

**Balbir Nazran**

**Sarla Parma**

*Group Leaders & Artist*

**Balbir Kaur Nazran**

**Eleanor Viegas**

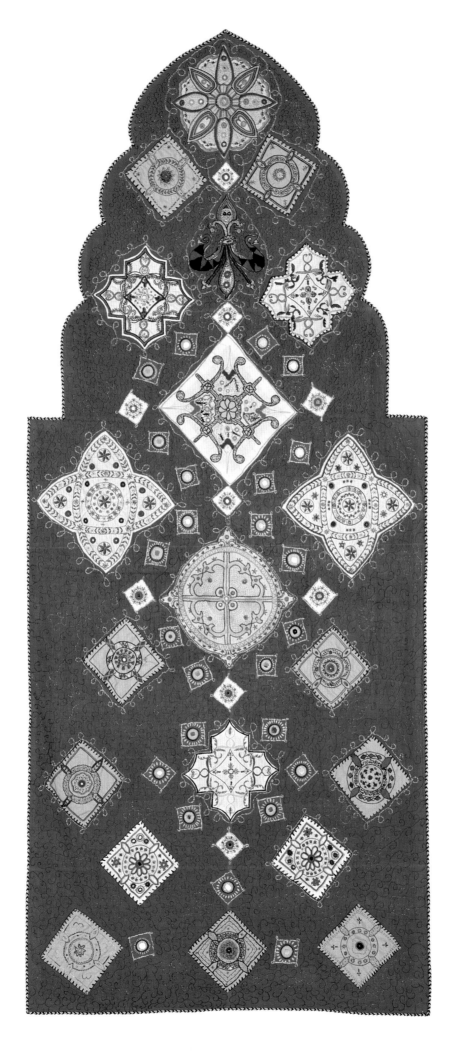

❖  ❖  ❖

# Reflecting a Vision of South African Culture 1996

Natal Museum
Pietermaritzburg, Republic of South Africa

'Our panel starts with the *SS Truro* – which carried the first indentured Indians to South Africa in 1860 – in the bottom of the central column and continues to recall how the first settlers worked on the sugar estates – a new agricultural crop for the developing colony of Natal. Patel's trading store is symbolic of the bringing of merchandise to the remotest areas of KwaZulu, Natal. The grave recalls when Indian families were uprooted from Pietermaritzburg; their possessions broken and destroyed....

'The Indo–African pot relates to our Indian–African culture; the meeting and melting of two cultures; a Zulu and Indian cultural blend. The books depict higher education and the vocational role Indian women now play in this country.... The boxes remind us of the apartheid era when the nation was divided into racial groups. On these boxes are the symbols of affluence and entertainment by the White group; growth is depicted on the next box – growth through suffering of the Indian group; hard labour in the form of spades and picks shows the Coloured group; the Black group is depicted by the political consciousness, the black fist, bloodshed; pain and the struggle. We are held together in unity, guided and supported by our spirituality, expressed in the various religious symbols.... The lamp symbolizes the beginning of a new era in South Africa, of our freedom for all.'

GROUP LEADER

Participants

Naseem Aboo
Vinesh Amichand
Vija Baijoo
Naseema Ballim
Ramola Chauhan
Pearl Chetty
Lorraine Chetty
Mercy Frances
Sheena Ganesh
Bhanu Ghela
Maya Hargovan
Kay Hiralall
Zubie Jogiat
Tiny Jugmohan
Shanita Jugmohan
Lalloo Madhuri
Shanti Maharaj
Gayathri Maharaj
Ishara Maharaj
Hemla Makan
Lallie Maney
Deepa Mathura
Cookie Mathura
Rajpathy Mohan
Neela Moodley
Nalienie Moodley
Nimmi Moodley
Manoo Moodley
Ashy Moorjee

Tilly Naidoo
Pridie Naiker
Denise Narrandes
Serchni Padayachee
Manju Parus
Manu Pillay
Saro Pillay
Revni Pillay
Charlotte Raman
Joy Raman
Ramela Ramday
Kamla Ramdeen
Yasmin Rannif
Devika Reddy
Sarla Sangham
Vidya Satgar
Rekha Singh
Premilla Singh
Sugar Soobedar
Gita Suparsad
Shano Supersad
Radha Vather
Brenda Vather

Group Leader

Linda Ireland

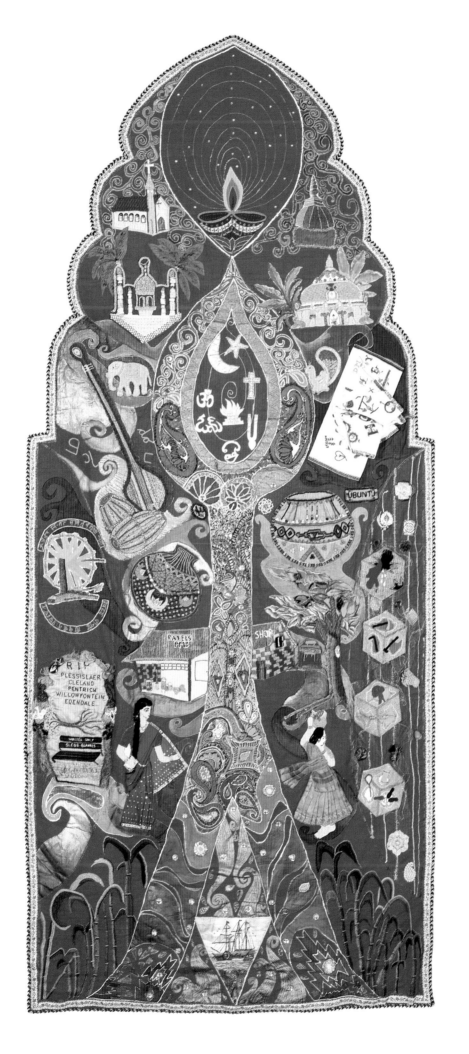

❖   ◆   ❖

# Bradford Pride: Fabric Fashioned in Friendship · 1997

Cartwright Hall Women's Group 1
Bradford, Yorkshire

'This hanging was produced in a community centre by a diverse Women's Group. Participants were from a broad age range and included members from the Muslim, Christian, Hindu, Sikh communities of Bradford. Despite linguistic, religious and cultural differences, the project enabled long-term friendships to be forged through the process of design and the production of the hanging.

'The group have shown pride in being Bradfordians, identified by the district's crest – the Yorkshire rose – and architectural landmarks of Bradford, which include the Alhambra Theatre, City Hall and the National Museum of Photography, Film & Television. As well as having this shared identity they were all keen to represent their own individuality here by the use of religious symbols and female figures in different attire.

'The central focus of the panel is the peacock, which was used by the group to symbolize beauty and prosperity. The feathers were decorated individually by each group using embroidery, beads and sequins. The whole image is illuminated by a dazzling sunburst motif located at the uppermost part of the hanging, which was inspired by items from the transcultural collection of Bradford Art Galleries and Museums.'

GROUP LEADER

Participants

*IDLE HANDS EMBROIDERY GROUP:*

**Betty Coleman**

**Glenys Rowe**

*BRADFORD CATHEDRAL:*

**Elizabeth Wash**

*THORNBURY MIDDLE SCHOOL:*

**Paula Davis**

**Arvinder Summan**

**Balques Younis**

*LAISTERDYKE WOMEN'S GROUP:*

**Najma Bibi**

**Nighat Farooq**

**Parveen Kauser**

**Rukhsana Kauser**

**Saeeda Khanum**

**Natasha Mahmood**

**Hajra Malik**

**Raqeeb Sultana**

*THORNBURY METHODIST CHURCH:*

**Gwyneth Brown**

**Mary Dinsdale**

*PARISH OF MANNINGHAM:*

**Linda Davies**

*KARMAND COMMUNITY CENTRE:*

**Parsani Kaur**

**Rabia Laher**

**Kishwar Mehmood**

**Suriya S. Mughal**

**Amina Yaqoob**

*DIXON CITY TECHNICAL COLLEGE:*

**Nusrat Afzal**

**Attia Bashir**

**Beenash Faris**

**Sobia Mir**

**Ambreen Mirza**

**Shahana Shad**

**Rebekah Wallbank**

*INDIVIDUALS:*

**Kartik Mason**

**Rukhiben Mistry**

Group Leaders & Artists

**Viv Benson**

**Rahila Habib**

**Saroj Joshi**

**Jaaya Kumari**

**Krishna Lal**

**Nilesh Mistry**

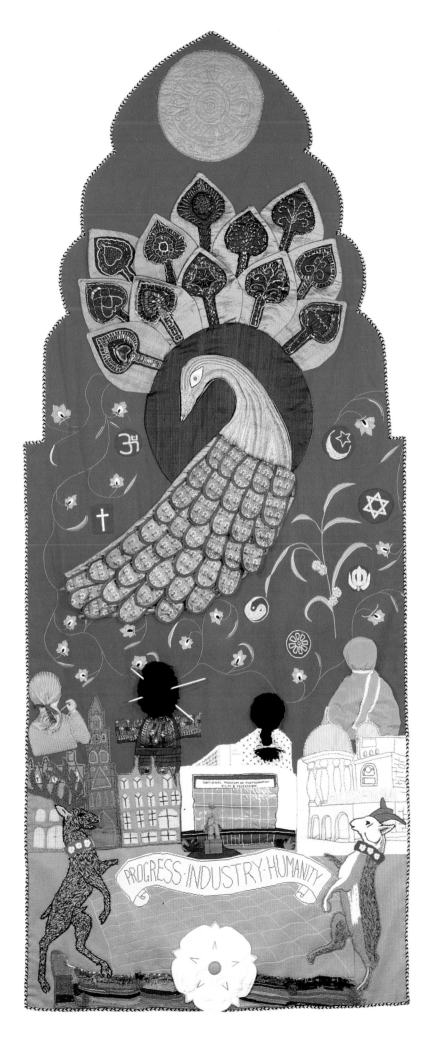

PROGRESS·INDUSTRY·HUMANITY

# South of the River
## 1997

### Bedford Women and Girls' Group
### Bedford, Bedfordshire

'Our panel mainly consisted of young Asian women dealing with everyday problems that any young person faces with the added phenomenon of being Asian. Put simply our panel represents our reflection of life for Asian young people.

'The panel has two trees as its centre piece, intertwined, creating something beautiful and magnificent not only upon the surface but deeper in thought and ideology. The two trees represent the cultural poles of the East and West; although different they are grown from the same earth. We attempted to show that we, the younger generation, have grown up with both cultures and from it created our own with attitudes and beliefs from both worlds. The roots of the tree are embedded in the River Ouse, which runs through Bedford.

'However, the *jali* represents barriers created by our own inhibitions which we still face. Through the *jali* we are able to see the beauty, creativeness and wide variety of benefits that can be obtained if we were to venture forth…. The hands at the top are representative of our ultimate goal of friendship and toleration between all people.

'Tears were shed and friendships were stretched throughout the making of the panel, not only marking the loss of those dear to us, but also the conflict we all underwent between ourselves, but also within us.'

PARTICIPANT

*Participants*

| | |
|---|---|
| **Niteshe Adia** | **Hardeep Lal** |
| **Nahid Akhtar** | **Pavinder Mann** |
| **Rubina Ansari** | **Michelle Matu** |
| **Furzana Ashraf** | **Rosalyn Matu** |
| **Shilpi Begum** | **Margaret Matu** |
| **Tamanna Begum** | **Rekha Mummom** |
| **Soiyna Begum** | **Shabeena Mussaret** |
| **Jubeda Begum** | **Aqsa Rafiq** |
| **Majeda Begum** | **Azra Rashid** |
| **Mohina Begum** | **Parvinder Sagoo** |
| **Seju Begum** | **Sarbjit Sheimer** |
| **Sofina Begum** | **Ravinder Sidhu** |
| **Lavely Begum** | **Tajinder Sidhu** |
| **Alma Begum** | **Shabana Zafar** |
| **Luthfa Begum** | |
| **Parbina Begum** | *Group Leaders & Artist* |
| **Hatecha Bibi** | **Hamider Awan** |
| **Hathema Bibi** | **Mervyn Bell** |
| **Shahida Bibi** | **Sally Freer** |
| **Firth Butt** | **Jenny Keanes** |
| **Becky Bygraves** | **Winnie Manning** |
| **Husna Choudhury** | **Kanchan Malde** |
| **Afeefa Fatima** | **Mary Spyrou** |
| **Manmeet Juttla** | **Linda Weerasiri** |
| **Neelam Kalyan** | |
| **Suehalna Khanom** | |
| **Shalma Khanum** | |
| **Naisha Khanum** | |
| **Neelam Kumari** | |
| **Gita Ladhar** | |

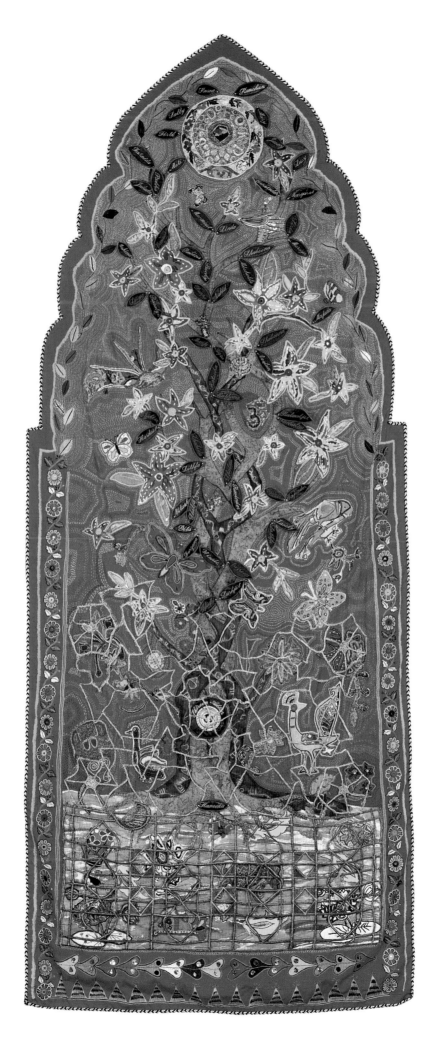

❖ ❖ ❖

# A Recipe for Unity, A Memory of Home
## 1997

### Ikat Arts Group, Malaysia

'The members of our group reflect the racial, religious and cultural diversity of Malaysia, our roots in Malaysia tie us together. Through our work on the panel – weaving and tying fragments of our recipes, distant memories and lost stories, we hope to illustrate our unity and diversity.

'The panel reflects an assortment of ideas, meanings and themes the group wanted to illustrate. Below is a short summary of the main ideas:

- The use of text as a form of pattern/decoration – we all came to the UK for educational reasons so text, books and language were important influences.

- Food recipes – food was a subject that united all the races. Malaysia has some unique dishes, created from the multicultural mix.

- Weaving – the use of strips of text on the fabric and ribbons to weave a pattern reflected the interweaving of the different races. Weaving is also a popular craft technique in Malaysia....

- Golden ribbon – the use of gold ribbon symbolized the importance of gold jewellery to all the women of Malaysia who collect it as a form of security. It also reflects the gold ribbon used in the fabric weaving of *songket*.

- Shadow Puppet (*Wayang Kulit*) – the shadow puppet as a background layer symbolized our lives. The shadow puppet is also another cultural form which unites the different races – it is performed by the Malays, uses the stories of Indian mythology and is watched by all.'

GROUP LEADER

*Participants*

**Roisin Ariff**

**Rosmimi Abdul Aziz**

**Colin Blake**

**Andrew Chan**

**Shalini Marimuthu**

**Monie Mohariff**

**Hayati Mokhtar**

**Dr Helen Muhiudeen**

**Clare Muhiudeen**

**Norhashima Yusuff**

*Group Leader*

**Zehan Albakri**

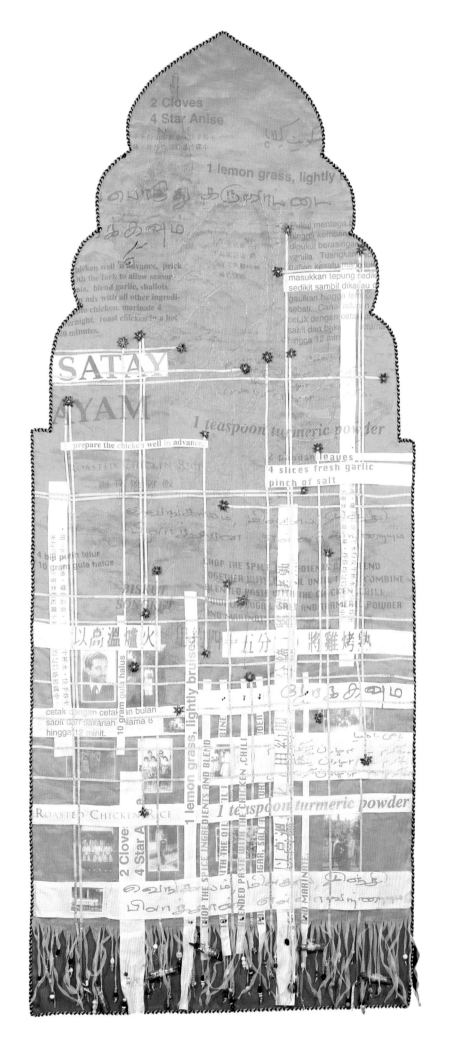

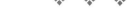

# Al Dalal · 1997

Tebra

Dubai, United Arab Emirates

'Tebra celebrates the creative talent of women artists in the United Arab Emirates. We have shown that a group of national women can work together to produce work that not only has artistic merit but also commercial potential.'

GROUP STATEMENT

*Participants*

**Hessah Maktoum Al Maktoum**

**Hessa Mohammed**

**Wafa Mohammed**

**Sawsan Al Qasimi**

**Najwa Al Rahma**

**Khulood Mattar Rashid**

**Manal Shamlan**

*Group Leader*

**Tina Ahmed**

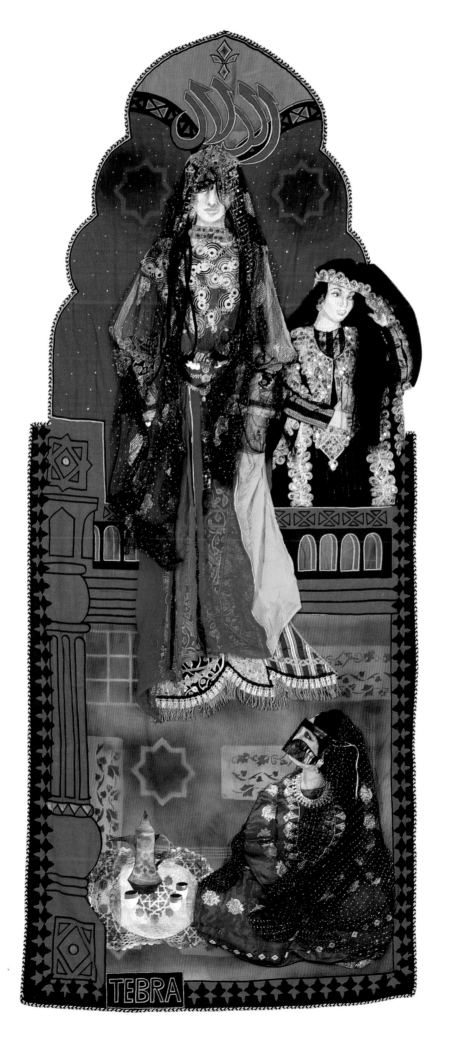

❖  ❖  ❖

# Working Mothers and Daughters · 1997

Aparajeyo Bangladesh
Dhaka, Bangladesh

*Participants*

**Asma**

**Baby**

**Latifa**

**Maya**

**Munni**

**Mursheda**

**Pakhi**

**Putul**

**Ranu**

**Ritu**

**Shahinoor**

*Group Leader*

**Ruby Ghuznavi**

'Aranya[Crafts Ltd] has sponsored this panel to ensure that Bangladesh's outstanding tradition of *kantha* embroidery is represented in the "Shamiana" exhibition. The panel is a tribute to Shireen who was also closely associated with Aranya in the early years. The girls wanted the panel to show the beauty of Bangladesh. "Bangladesh is not just a country of floods and cyclones; it is a beautiful country with hard-working people, especially the women", said Asma. Mursheda, due to sit her BA Hons this year, wants to project the strides of women: "Not only do we do a major part of the agricultural work, we are also in the garments and electronics industry; today there are women civil servants, doctors, pilots...."

'Everyone wanted their panel to communicate an upbeat and hopeful mood. With this in end in view, the panel was divided into sections. On the right, scenes of rural women at work are depicted: agricultural and post-harvest work; women in the marketplace, selling fish, tailoring, riding a bicycle, etc. The left section shows the garment workers, electricians, a woman bureaucrat, a driver and a pilot.

'The mihrab has been specially selected to represent the Islamic designs and colours of the Mughal miniatures. Except for the black and red, all other colours are from natural yarn. The most important feature of the *kantha* is the fineness of the background quilting, done with tiny running stitches, to create the ripple effect. A variety of stitches are used for patterns and motifs traditionally drawn from the images of fertility, prosperity and peace. In the present piece, the group has chosen to represent options available to women today and their ability to make decisions for themselves....'

GROUP LEADER

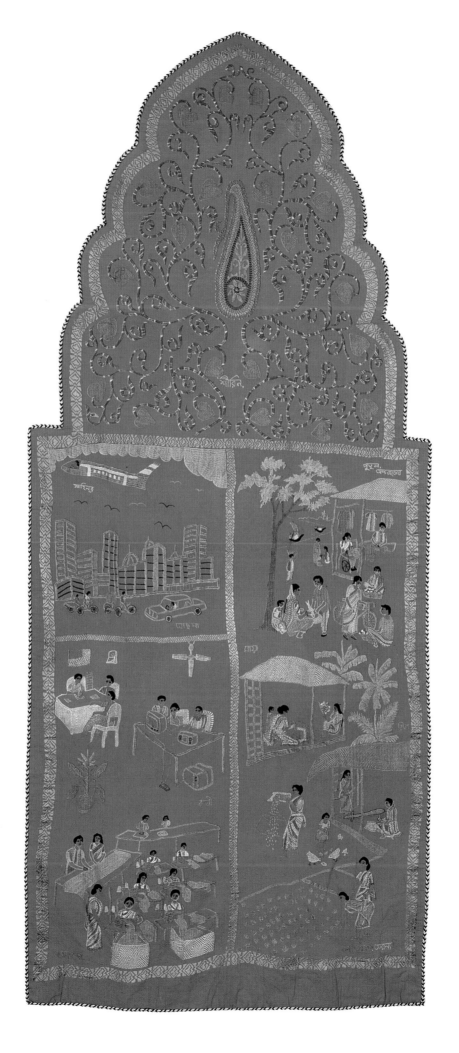

# Lantilleana – The Essence of Women of the Caribbean 1997

Paddington Youth Project Girls' Group
Westminster, London

'Our panel is inspired by the words of Claudia Jones: "I think of my mother, my mother a machine-worker in a garment factory... I began then to develop an understanding of the suffering of my own people and my class and to look for a way to end them." Like Claudia we are taking the first step to help ourselves and progress.'

GROUP STATEMENT

*Participants*

**Chantel August**

**Leonie Bishop**

**Kristal Edmunds**

**Hannah Francis**

**Jamilla Herman**

**Michelle Jeans-Charles**

**Samma Joseph**

**Sardie Joseph**

**Nina Lansiquot**

**Sabrina Tohn Lewis**

**Kamara Lionel**

**Lavanna Mullings**

**Taituo Scarborough**

**Ashanti Smith**

**Sophie Spiro**

**Gayle Tobias**

*Group Leaders & Artists*

**Sylvia Andrews**

**Dawn Howe**

**Pat-C. Jaggs**

**Sarbjit Natt**

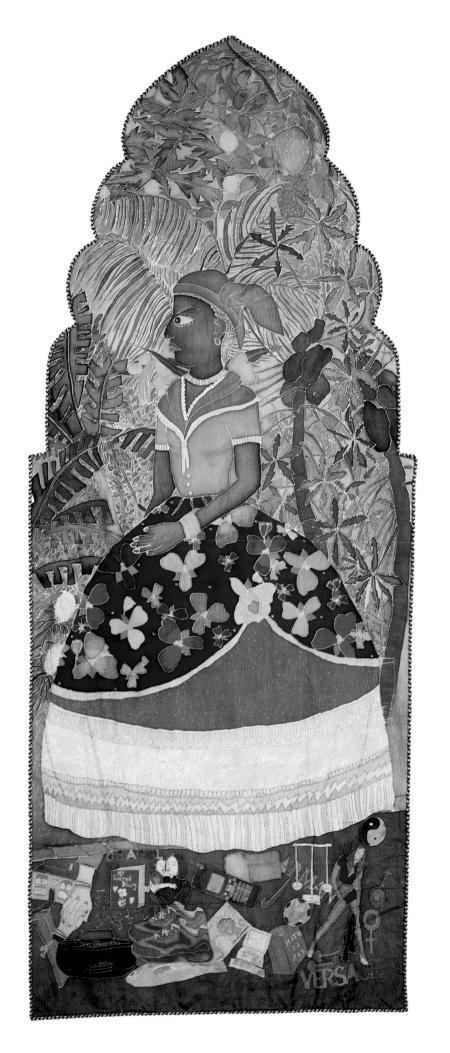

❖  ❖  ❖

# Bradford Celebrates · 1997

Cartwright Hall Women's Group 2
Bradford, Yorkshire

'Produced by a group of women and girls drawn from the surrounding area of Cartwright Hall Art Gallery, this panel reflects the multicultural nature of Bradford and incorporates the contributions made by British–Asians.

'The central map depicts Britain, India and Africa, which are the countries of origin of the group members. This is encircled by a sun motif from which the sun rays extend, leading to images of some of Bradford's achievements. This includes the city seen as the curry capital of Britain, the National Museum of Photography, Film & Television and the wool industry which attracted migrants to the city – represented by the sheep and doll-size costumes. The female Asian hands cupping the globe is the symbol of women's empowerment, achievements and contribution to the society here in Britain and in the Indo–Pakistan continent.

'The background is Lister Park, which houses Cartwright Hall, and is also the venue of Britain's largest Asian Mela, part of the annual Bradford festival…. At the base of the panel are the ornate Victorian park gates which are the main entrance to Lister Park. The gates are left open to welcome the viewer into the park to share its beauty.

'The two Cartwright Hall panels were nearing completion when we heard of the tragic death of Shireen Akbar. There was tremendous sadness and feelings of loss felt by group members and so the group decided to pay a tribute to Shireen in their panel and placed it on the gate pillars.

'On completion of the project some of the women with enthusiasm went on to have embroidery sessions at their centre and more recently are planning to produce their own version of a wall hanging.'

GROUP LEADER

*Participants*

ASIAN WOMEN'S CENTRE:

**Kausar**

**Naseem**

FRIZINGHALL WOMEN'S GROUP:

**Naiem Akhtar**

**Zameeda Bi**

**Tasveer Ghani**

**Gulshan Munir**

**Noreen Razak**

**Zebunnisa Rehman**

**Zohra Tariq**

INDIVIDUALS:

**Usha Chand**

**A. Karandikar**

**Kundan Shah**

MILAN CENTRE:

**Jamila**

**Syeeda Fatima**

**Latifa**

IDLE HANDS EMBROIDERY GROUP:

**Mary Dean**

**Kartik Mason**

**Salima Moochhala**

*Leaders*

**Kaniz Actar**

**Nasreen Butt**

**Jaaya Kumari**

**Nilesh Mistry**

**Saleem Sabir**

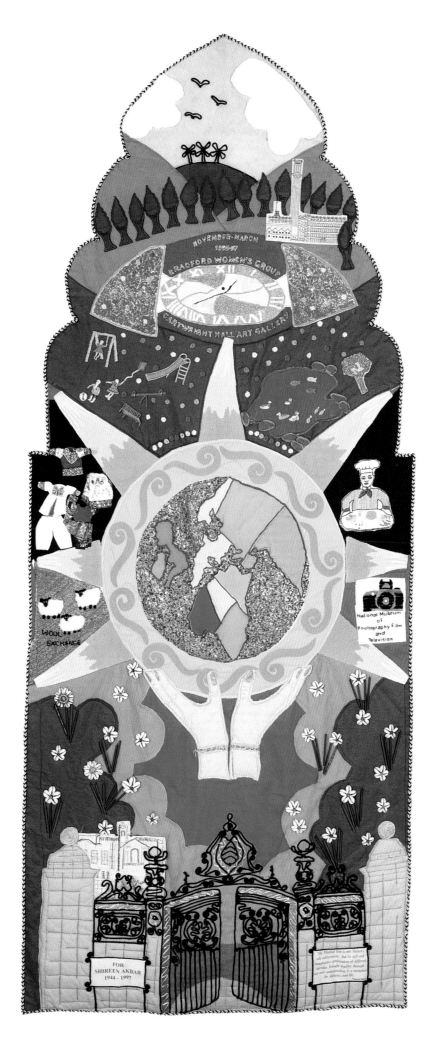

# Conclusion
## The implications of the project

David Anderson

Shamiana: The Mughal Tent was a project of profound museological significance. Deeply rooted in multiple cultural traditions, it pointed a way forwards for the Victoria and Albert Museum as a contemporary institution more clearly than any other project the museum has undertaken in recent years. Objects do not in themselves represent culture; rather culture comprises the engagement of human minds and hearts, through experience of artefacts and other museum resources. It is the responsibility of museums and galleries to help each generation to re-engage with the cultural resources they hold in their collections, sites and skills, and by doing so, to contribute to what the philosopher Michael Oakeshott has described as 'a public conversation across the ages'.

An EC-funded meeting in Liverpool in 1998 to discuss the future of museums proposed a new definition of a museum as 'a framed experience rooted in authenticity'.[1] The definition liberates the museum from the walls of the institution, and locates it securely within each of us as a way of thinking, a dimension of all human life, that the physical museum at its best may represent but not contain.

The challenge today to the traditional museum comes principally from two sources. The first is the community. The publication in 1997 of the government's Green Paper, *The Learning Age*,[2] marked the point at which the focus of public education policy shifted decisively from a twentieth-century, supplier-led model

of provision by educational institutions such as schools and colleges, to a demand-led model in which individual learners have far greater autonomy and responsibility for charting their personal development through life. The work of government now is not to fund the formal education system, but rather to ensure that individuals have learning opportunities and support in many places in their communities – in libraries, museums and galleries, and the home, as well as at work, and in traditional educational sites.

We are witnessing a revolution in public policy that is without precedent in this century. In this context, Shamiana can no longer be regarded as a marginal project conducted on the fringes of museums with marginal groups, but rather as an example of what museums must and will become – institutions that are rooted in their communities.

What Shamiana demonstrated beyond question is the capability of the public using their own skills, imagination and social understanding, to create works of art of extraordinary beauty and expressiveness. The sum of the expertise and skills in the communities around museums is greater by far than that of their staff within, and no museum open today could operate successfully without drawing heavily on this expertise. This has always been acknowledged by museum staff in the academic domain, but largely denied in other respects.

The second significant challenge to the traditional museum comes from the virtuality of digital media. In the digital world, what is distinctively 'museum-like'? This is a question the V&A is now attempting to answer by translating the Shamiana Project on to the Web. The purpose of this initiative is to discover if youth and community groups, as well as schools, colleges and cultural institutions, can participate in the project through the Internet in a way that retains the spirit of the original project.

In order to do this, the museum has tried to define what it is that is distinctive

about museum learning in general, and the Shamiana Project in particular. Such a question is not easy to answer. Museums are public spaces which people enter voluntarily for experiences through sensory contact with authentic cultural resources. They are intrinsically learning environments. None of these characteristics, taken in isolation, is unique to museums, but when combined, they become a powerful creative medium that complements rather than replicates other media such as broadcasting. All of these characteristics also can probably be represented, with integrity, in the digital environment, given care and imagination; but few museums have yet managed this successfully.

The spirit of the Shamiana Project is even more difficult to capture virtually than that of museum exhibits. The project's core learning unit is the group – not the individual. The design and making of panels was a group activity, and the results of this activity were textile panels of a common physical size and shape, capable of being displayed together in an exhibition in a single physical location. Most groups joined the project as a result of personal networks, rather than impersonal electronic communication. Yet there is no pure virtuality, any more than there is pure actuality. A digital manifestation of the Shamiana Project must of necessity have some physical manifestations as well – the skill in educational terms will lie in the development of an effective combination of these.

Shireen Akbar and the groups with whom she worked have created in the Mughal Tent Project a model for community-based arts education work that is innovative, transcultural, transgeneration and educationally robust. Its methodologies can be used by any community group using any cultural resource. One of the reasons for the success of the model is the essential simplicity of its features – the emphasis on field-dependent self-directed learning by groups; the development by all participants of a clear framework (the creating of a textile panel within a mihrab form); and a common purpose (an exhibition within a tent). The project had a co-ordinating body (in this case, the V&A) in an enabling, rather than a

commissioning, role which left plenty of scope for local initiative and choice.

Few who work in museums questioned the validity of the Mughal Tent Project in educational terms. Most museum staff also felt that the display of the works created by the women and children who participated in the Mughal Tent Project was of critical importance. Some others, however, did question whether the resulting panels should have been displayed to the public in the Victoria and Albert Museum. The reason for their concern was that the museum was giving the panels a status equal to that of the collections, all of which had been selected because they represent (in the opinion of those who acquired them for the museum) the most influential and innovative artefacts of their type.

Central to this debate is the concept of excellence. Traditionally, museums have defined excellence in terms of the quality of the products (objects). This is a narrow and ultimately anti-intellectual approach. Today, museums as public learning institutions should be concerned with excellence of learning process and experience, as well as with excellence of product. Above all, Shamiana is a celebration of human creativity – that of the makers of the V&A's core historical collections, as well as that of the project participants.

It is now nearly a decade since the Mughal Tent Project began. Today the project's influence continues to spread, as both the adult education and art sectors see the educational potential it reveals. Shamiana is a mother with many children, from the V&A's Spiral extension, which will be built on its principles of community education, to a thousand future actions by those who were personally involved in the project, and whose lives were changed by the experience.

Notes

[1] Museums & Galleries Commission, *European Museums Beyond the Millennium* (London, MGC 1998).

[2] Department for Education and Employment, *The Learning Age* (London, DfEE 1998).

# Supporting Organizations

## UK Museums and Art Galleries

*Birmingham:* Aston Hall; Birmingham Museum and Art Gallery; Midland Art Centre. *Blackburn, Lancashire:* Blackburn Museum and Art Gallery. *Bradford, Yorkshire:* Cartwright Hall, Bradford Art Galleries and Museums. *Brighton, Sussex:* Corn Exchange. *Burnley, Lancashire:* Mid-Pennine Gallery. *Clitheroe, Lancashire:* The Platform Gallery. *Glasgow, Scotland:* Needleworks. *Halifax, Yorkshire:* Bankfield Museum. *Hove, Sussex:* Hove Museum and Art Gallery. *Leicester, Leicestershire:* Leicestershire Museum and Art Gallery. *London:* Victoria and Albert Museum; Whitechapel Art Gallery. *Redditch, Worcestershire:* Forge Needle Museum. *Taunton, Somerset:* Castle Museum. *Wolverhampton, Staffordshire:* Bilston Art Gallery.

## UK Civic and Community Organizations

*Bedford, Bedfordshire:* Bedfordshire County Council, Department of Education, Arts & Libraries – Community Youth Service; Elstow Craft Centre; Mehfil-e-Tar; Westbourne Community Centre. *Berkshire:* Berkshire County Council Education Department, Equality Section. *Birmingham:* Aston Hall Asian Women's Textile Group. *Blackburn, Lancashire:* Ethnic Minorities Development Association. *Burnley, Lancashire:* Stoneyholme and Danehouse Youth and Community Centre. *Burton-upon-Trent, Staffordshire:* Burton Caribbean Ladies' Group, Queen Street Community Centre; Voluntary Service Centre; Borough of East Staffordshire Leisure Services. *Cambridge, Cambridgeshire:* Eastern Arts Board. *Castle Cary, Somerset:* Ansford Community School, Somerset County Council's School Arts Fund, The Multi-Cultural Unit. *Croydon, Surrey:* Bangladesh Welfare Association. *Falkirk, Scotland:* Falkirk Community Education Service, Women and Equal Opportunity Unit, Falkirk Community Arts Project, Splinter Community Arts, Scottish Arts Council. *Glasgow, Scotland:* Needleworks. *Lancashire:* Lancashire County Council. *Leicester, Leicestershire:* Leicestershire Museums Service; Shama Women's Group. *London:* Britain Burma Society; Calthorpe Project, Camden; Hopscotch Asian Women's Centre, Camden; King's Cross Neighbourhood Centre, Camden; Bryony Women's Centre, Hammersmith and Fulham; Hammersmith and Fulham Asian Youth Project; Hammersmith and Fulham Ethnic Minorities Project; Burdett Eagles Girls' Group, Poplar; 'A' Team Arts Education, Tower Hamlets; City Challenge Language 2000

Group, Tower Hamlets; Jagonari Asian Women's Centre, Tower Hamlets; Steel's Lane Health Centre, Tower Hamlets; Stepney Girls' Group, Tower Hamlets; Tower Hamlets Youth and Community Education Service; Westminster City Council; Paddington Youth Project, Westminster; LEA Professional Development Centre. *Loughborough, Leicestershire:* Loughborough Design and Textile Group. *Mitcham, Surrey:* Ethnic Minority Centre. *Oxford, Oxfordshire:* Oxford City Council. *West Midlands:* Sandwell Metropolitan Borough Council, Sandwell Arts Development; Tipton City Challenge; Tipton Muslim Community Centre; West Midlands Arts. *Woking, Surrey:* Woking Asian Women's Association; Woking Borough Council; Woking Social Services.

## UK Schools, Colleges and Universities

*Bedford, Bedfordshire:* John Bunyan School. *Birmingham:* East Birmingham College. *Burton-upon-Trent, Staffordshire:* Burton Technical College. *Castle Cary, Somerset:* Ansford Community School. *Leicester, Leicestershire:* De Montfort University. *London:* Highfield Junior School, Enfield; Fulham Cross School, Hammersmith and Fulham; Sweet Union School, Hammersmith and Fulham; Blue Gate Fields Infant School, Tower Hamlets; Sir John Cass Foundation Primary School, Tower Hamlets; Tower Hamlets College of Further Education. *Slough, Berkshire:* Godolphin Infant School; Montem Infant School. *Windsor, Berkshire:* Windsor Girls' School.

## Overseas Museums, Galleries and Community Organizations

*Bangladesh, Dhaka:* Aranya Crafts Ltd. *Burma, Mandalay:* Ma Tu's Group. *European Community, Brussels:* Espace Leopold, European Parliament. *India, New Delhi:* The British Council; Dastkar. *Gujarat:* Sewa Banaskantha & Dastkar. *Madras:* Government Museum. *Malaysia:* Ikat Arts Group. *Pakistan, Karachi:* The Karigari Group. *Republic of Ireland, Dublin:* West Tallaght Women's Textile Group; The Chester Beatty Library and Gallery of Oriental Art. *Republic of South Africa, Pietermaritzburg:* Midlands Museum Forum; Natal Museum; Tatham Art Gallery, Pietermaritzburg-Msunduzi Transitional Local Council. *United Arab Emirates, Dubai:* Tebra; Women's Society of the UAE. *United States of America, New York:* Long Island Women's Group. *Los Angeles:* Los Angeles Women's Group.

# Shamiana: The Mughal Tent

Exhibition Tour Venues (from June 1997 *until December 2000*)

**VICTORIA AND ALBERT MUSEUM**    *26 June – 14 September 1997*

Cromwell Road, LONDON

*Tent and 56 panels*

**ROYAL MUSEUM OF SCOTLAND**    *10 October – 8 December 1997*

Chambers Street, EDINBURGH

*14 panels*

**RAGGED SCHOOL MUSEUM**    *14 January – 26 March 1998*

46-50 Copperfield Road, LONDON

*4 panels*

**WORLD TRADE CENTRE**    *17 March – 25 March 1998*

DUBAI, United Arab Emirates

*30 panels*

**ST PAUL'S CHURCH**    *7 May – 31 May 1998*

Bow Common, LONDON

*30 panels*

**ART GALLERY AND MUSEUM**    *9 October 1998 – 4 January 1999*

Kelvingrove, GLASGOW

*40 panels*

**SLOUGH MUSEUM**    *1 March – 30 April 1999*

278/286 High Street, SLOUGH

*12 panels*

EXHIBITION TOUR VENUES

**CLOCKTOWER** *13 March – 26 March 1999*

Katharine Street, CROYDON

*3 panels*

**LEICESTER CITY MUSEUMS SERVICE** *17 July – 27 September 1999*

New Walk Museum & Art Gallery, 53 New Walk,

LEICESTER

*15 panels*

**CARTWRIGHT HALL** *16 October 1999 – 2 January 2000*

Lister Park, BRADFORD

*18 panels*

**Tour Venues for 2000** (to be confirmed)

**ASIA TOUR**

*Tent and 22 panels*

**BIRMINGHAM MUSEUM AND ART GALLERY**

BIRMINGHAM

*Tent and 22 panels*

**IRISH MUSEUM OF MODERN ART**

DUBLIN

*Tent and 22 panels*

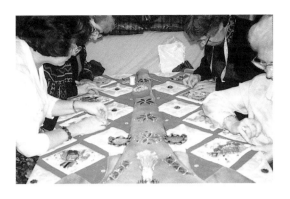

# Index of Panels